LEGENDARY LOCALS

— OF —

AUBURN

INDIANA

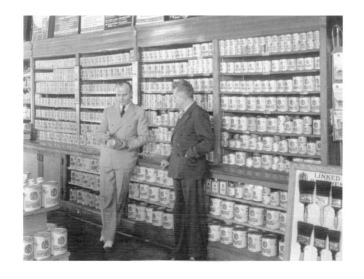

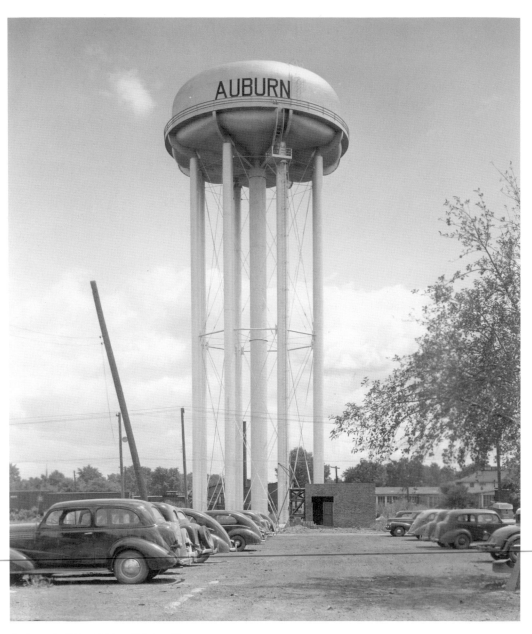

Auburn's West Edge Water Tower
The city's water tower on the west edge of town, located on Eleventh Street, can be seen from many areas of the community. This photograph was taken in 1949, and while the color of the tower may have changed a time or two, it remains as a visible reflection that an active and vibrant community gathers in Auburn. (Courtesy of the William H. Willennar Genealogy Center.)

Page 1: Pioneers of Hardware
This is a photograph of Ed Kokenge (left) and William Cooper, owners of Auburn City Hardware. They are standing in front of a paint display. Kokenge purchased Cooper's share of the business in 1939. (Courtesy of the William H. Willennar Genealogy Center.)

LEGENDARY LOCALS

OF

AUBURN

INDIANA

CHAD GRAMLING

LEGENDARY
LOCALS

Copyright © 2014 by Chad Gramling
ISBN 978-1-4671-0109-7

Legendary Locals is an imprint of Arcadia Publishing
Charleston, South Carolina

Printed in the United States of America

Library of Congress Control Number: 2013939797

For all general information, please contact Arcadia Publishing:
Telephone 843-853-2070
Fax 843-853-0044
E-mail sales@arcadiapublishing.com
For customer service and orders:
Toll-Free 1-888-313-2665

Visit us on the Internet at www.arcadiapublishing.com

Dedication
To my daughters, Daphne, Stella, and Amelia—may you become legendary locals among your generation and inspire those yet to come.

On the Front Cover: Clockwise from top left:
W.H. McIntyre and Harry G. Henry in a Milwaukee Steamer (courtesy of the William H. Willennar Genealogy Center; see page 37), Ed Kokenge and William Cooper at Auburn City Hardware (courtesy of the William H. Willennar Genealogy Center; see page 30), Martha "the Popcorn Lady" Falka (courtesy of the William H. Willennar Genealogy Center; see page 119), Fred Ball at Ball Brass (courtesy of Jennifer Fahlsing; see page 44), classic buildings and local legends converge for worthy cause (courtesy of the William H. Willennar Genealogy Center; see page 124), Manon Service Station (courtesy of the William H. Willennar Genealogy Center; see page 97), Mayor Jack Foley and friends (courtesy of the William H. Willennar Genealogy Center; see page 98), Rollie Muhn as Santa (courtesy of the William H. Willennar Genealogy Center; see page 113), Auburn photographer Kelso Davis (courtesy of the William H. Willennar Genealogy Center; see page 54).

On the Back Cover: From left to right:
Early photograph of Double Fabric Tire Company (courtesy of Jennifer Fahlsing and the Ball Family; see page 26), Glenn and Thelma Rieke (courtesy of the William H. Willennar Genealogy Center; see page 38).

CONTENTS

ACKNOWLEDGMENTS

The author wishes to thank those historians of Auburn and DeKalb County past and present. For, without their efforts, this book may not have been possible. Among those historians are, but not limited to, William H. McIntosh, John Martin Smith, and John Bry. Additionally, I wish to thank those photographers who have chronicled our history, specifically Kelso Davis; his wife, Margaret; and Roberta Andres. It is also with sincere gratitude that I thank the staff of the William H. Willennar Genealogy Center for their kind assistance in helping me locate photographs and information. I also wish to thank a few other individuals who have provided their support and/or assistance in one way or another. Notably, and in no specific order, Mike Littlejohn, the DeKalb County Genealogy Society, Jaynie Krick, Brad McDaniel, Brad and Elaine Middleton, Mayor Norm Yoder, David Wolff, Jennifer Fahlsing, Blake Sebring, Keith Sexton-Patrick, John Calvin Manon, Diane Manon, Mary Ellen Bausch, David Turner, Dawn Immel Akins, Dave Kurtz, KPC Media, Dotty Miller, John Souder, Ellen England, and Jon Bill. And finally, I thank my wife, Jennifer, for her support and gracious yielding of time as I worked on the book.

John Martin Smith once observed that writing about your hometown has a tremendous responsibility. I found out just how correct he was in that assessment. I therefore feel it appropriate to acknowledge that there are (perhaps many) legendary locals who are not included in this book. The reasons for that include lack of photographic representation, insufficient information for a narrative to accompany the photograph, and the simple fact that I am human and prone to oversight. Such omissions, no matter how large or small, were not personal, nor were they intentional.

INTRODUCTION

It is eminently proper to venerate the past, and to speak reverently and respectfully of those who lived in it. But it is not profitable to spend our time in mourning for the "good old times," or in sighs and vain regrets.
—Frank M. Powers

While I was working on *Legendary Locals of Auburn*, I had the good fortune to meet many living local legends as well as friends and family of several of those who have since passed their torches on to new generations. In some cases, these men and women are people I had only ever heard of or seen casually but never personally known. In some cases, they were individuals I had served as a child when I would bring them their daily newspaper. And of course, some of them are people I have known for many years and consider good friends.

I am both fortunate and honored to have the opportunity of telling their stories. The chance to further one's learning with the wisdom and experiences of local legends such as these should not be taken lightly. There are countless others who, unfortunately, were not able to be included. Hopefully, you will consider this an opportunity to further your own research and uncover the stories of others. This book is not the all-encompassing lesson. Rather, let it be merely the beginning!

As I embarked upon the rigorous task of obtaining photographs, doing research, and preparing the layout for this book, I began observing connections between several local legends, and I started to find that some narratives would cross each other or carry minor elements of another I had recently learned or written about. Almost always, yet another thread was there to be followed.

Toward the end of producing the manuscript, I heard of an individual (not from Auburn), who had built her business culture upon an Asian legend that is known as, among other monikers, the red thread theory. As the story goes, when a baby enters the world, there is a figurative red thread tied around his or her ankle and one of the ankles of all of the people that child will connect with during his or her lifetime. That thread may get tangled, stretched to perceived limits, and a host of other machinations, but it does not break. As I read of this, I realized that in doing this book, I have come to characterize the community in a similar regard. We are all babies born into a massive world. Some of us wander from one community to the next, but many of us will ultimately take up permanent residence in a location of comfort, security, or peace—Auburn.

Whether we are nomads or mainstays, we all are contributors to community. We bring something of impact to the here and now. We connect with one another to share knowledge, resources, and abilities while forming a unique bond that defines our identity and builds lasting memories that shape our mini-culture. Along the way, and over time, standouts emerge and they are soon on their way to becoming legends.

The local legends you will read about in this book have all impacted Auburn in some manner. Some were seemingly instant, and some incubated for years. Some impacts are more obvious than others, but they all represent contributions to the core of defining who we are as a city and a community.

In describing *Legendary Locals of Auburn* as I assembled the content, I often told people that it is a book for telling the stories of those who created the very fabric of Auburn and Indiana's modern identity as well as those who are forming the direction for what we will become. Taken in that context, we can trace that thread from the humble beginnings of Wesley Park, who deliberately sought a location worthy of being called the "Loveliest village of the plain" to those who, as one local legend, Mike Littlejohn, states, "are just caretakers for our little pieces and places in time." We are all at work together to make our community the best it possibly can be for the now and for the future generations that are yet to come. This book tells the stories of those people as well as the men and women who shaped the moments that fall in between.

Each chapter of the book begins with a brief quote from one of the legendary locals of Auburn. They are used to establish context that will help guide that common thread.

The first chapter starts, appropriately, with the founders and pioneers of Auburn. Of course, it shares the story of Wesley Park, but there are many others who helped to build Auburn into a thriving community.

Chapter Two is one of the larger chapters as it threads our narrative through the lives of Auburn's leaders of business and industry. A common theme throughout the book is that of determination and reinvention. While it is not an attribute that is limited to business professionals, many of those stories come courtesy of these men and women.

The individuals presented in Chapter Three are a modestly sized grouping of artists and artisans within the Auburn community. Chapter Four recognizes the able-minded educators and the informers who ensured Auburn's citizenry were given the full opportunity to learn as well as continually gain knowledge, understanding, and connection throughout life.

The fifth chapter is another large chapter, containing local community leaders and servants, including mayors, councilpersons, doctors, and a host of others who found ways to make a difference. These individuals have ensured safety and comfort for the community while stoking the fire of forward momentum of civil progress.

Chapter Six pays homage to the entertainers and athletes who performed for us on their given stages while the seventh and final chapter ties together the legendary locals who managed their lives in ways that ensured nobody could ever fit their story into any one specific category or mold. They are the icing on our cake, the spike in our punch, the newsmakers and unforgettables. They are the adornment of our outfits, ably secured by the common thread that unites us.

CHAPTER ONE

Pioneers and Founders

The man who to himself says, "The aim of my life will be to gather money by toil, intellectually and physically, and hoard it away and live for myself only," will find life a dismal failure, but there are not such men in Auburn.

—Thomas Marshall

Then governor and future vice president of the United States Thomas Marshall spoke these words during a ceremony commemorating the 1910 installation of the cornerstone for the Eckhart Public Library.

These ceremonies have become an important cultural standard, offering symbolic context, because pioneers and founders, by nature, place the first stones, from which all future progress will be figuratively and literally built upon.

Whether by accident or intention, Auburn has been blessed with founders and pioneers in many forms. As a result, it is a community that has continually found new ways to reinvent itself as needed while holding true to its identity. Sometimes, the pace of progress has not been as constant, obvious, or rapid as some had desired. In fact, Auburn's founding father, Wesley Park, the man who cast that first cornerstone for placing the community, is said to have eventually left due to frustrations stemming from a perceived lack of progress in forging ahead.

Undeterred, however, the Auburn community moved on and rose above through the labor of men and women like Charles Eckhart, William H. McIntosh, Egbert and Mary Mott, Dr. Lida Powers Leasure, William H. Willennar, and more. Not only did they give of their time and talents, citizens are forever indebted to their goodwill, generosity, and their care for others within their community.

The narratives of the men and women represented within this chapter on founders and pioneers, like so many, could have been positioned in perhaps any of the other chapters of the book. However, it is undeniable that their rightful recognition is at the very foundation of any book about Auburn, Indiana, and the rich heritage it holds.

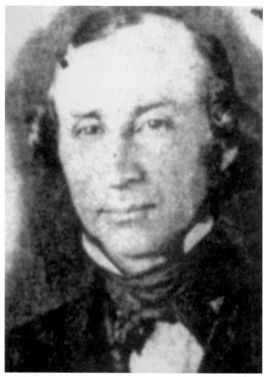

Wesley Park

Wesley Park was an enterprising man. Prior to his coming to the area that would become Auburn, he recruited Company K of the 44th Indiana Infantry Regiment and served as captain until he resigned in 1861 with what he called a "disability." Months later, he became a sutler to the 44th, serving as a private merchant with the consent to sell liquor, tobacco, candy, and other incidentals. In 1835, Park arrived in northeastern Indiana with George Stone and Hiram Johnson. His companions established a tannery in present-day LaGrange County. Unsatisfied with the area, Park left for Ohio and returned in 1836 with cattle and fruit that he sold. While on that business, he met John Badlam Howe, who was a lawyer and member of the Indiana General Assembly. The two journeyed to DeKalb County and sought an area of land that could become the county seat. Park, with the help of Howe, founded Auburn and got it named the county seat. Soon, his family joined him in the newly created settlement, and Park went to work promoting the community. In 1849, the unincorporated village became a town and, later, a city in 1900. In 1856, Park lent more than six acres to the DeKalb County Agricultural Society to host fairs. Park would also use the land at other times as a pasture and meadow. Later in life, Park became dissatisfied with the pace of Auburn development and left the community for Missouri. Unfortunately, he did not live to witness the substantial growth that Auburn later experienced. (Both, courtesy of the William H. Willennar Genealogy Center.)

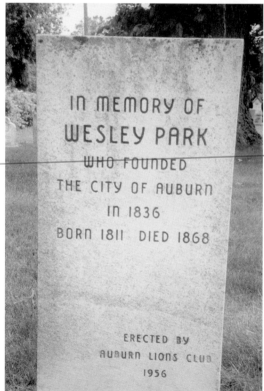

IN MEMORY OF
WESLEY PARK
WHO FOUNDED
THE CITY OF AUBURN
IN 1836
BORN 1811 DIED 1868

ERECTED BY
AUBURN LIONS CLUB
1956

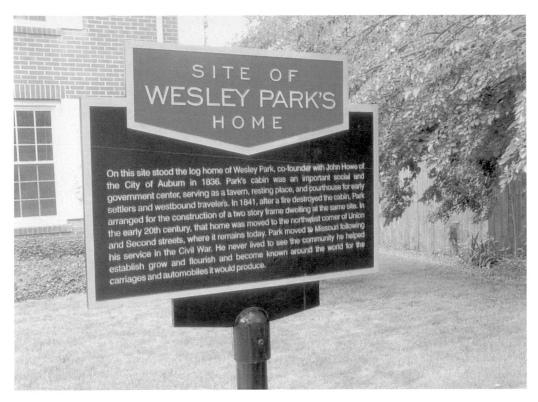

SITE OF WESLEY PARK'S HOME

On this site stood the log home of Wesley Park, co-founder with John Howe of the City of Auburn in 1836. Park's cabin was an important social and government center, serving as a tavern, resting place, and courthouse for early settlers and westbound travelers. In 1841, after a fire destroyed the cabin, Park arranged for the construction of a two story frame dwelling at the same site. In the early 20th century, that home was moved to the northwest corner of Union and Second streets, where it remains today. Park moved to Missouri following his service in the Civil War. He never lived to see the community he helped establish grow and flourish and become known around the world for the carriages and automobiles it would produce.

Wesley Park Homestead

In the fall of 2012, Dr. Donald and Nancy Derrow began working with DeKalb County historian John Martin Smith to recognize the historical significance of their property, which is the site where Wesley Park built his log cabin in 1836. Upon Smith's passing, the Derrows turned to his successor as county historian, John Bry, for help. Using maps, oral historical records, articles, and census information to research the site's history, they placed this marker on the lot to symbolize Auburn's beginning. After being the home of Wesley Park, the site went on to become an important social and government center, serving as a tavern, resting place, and courthouse for settlers and travelers. A fire destroyed the cabin in 1841. Park had a two-story frame home constructed in its place. That home was later moved to the northwest corner of Union and Second Streets and still stands as of this publication. (Author's collection.)

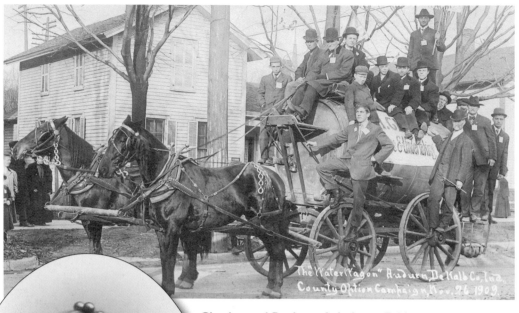

The "Water Wagon" Auburn, DeKalb Co., Ind. County Option Campaign, Nov. 26, 1909.

Charles and Barbara Ashelman Eckhart

Charles Eckhart, born in Germantown, Pennsylvania, is revered as one of Auburn's most successful businessmen and generous benefactors. Along with his son Frank, he directly contributed to the development of the YMCA on Main Street, the Eckhart Public Library, Eckhart Park, and more. At age eight, Charles worked in his father's woolen mill and later apprenticed himself to a carriage maker when the mill closed due to an economic recession in 1857. He purchased that shop at age 19 before enlisting in the Civil War. Following the war, he briefly worked as a carriage maker in Kendallville, meeting his future bride, Barbara Ellen Ashelman (left), during a visit to Waterloo. After a series of moves relating to the availability of work, they settled in Auburn in 1874 and established the Eckhart Carriage Company using the parlor of their home on East Seventh Street (the Ashelman house) for production of the carriages. The company grew tremendously, becoming capable of producing 5,000 carriages a year and employing 125 workers at its peak in 1906. Charles's sons Frank and Morris began helping him as soon as they were old enough to work, and were soon tinkering with early motors at the shop. Their experimenting led to the eventual founding of the Auburn Automobile Company. Charles Eckhart had retired from business around 1895, providing him with time to work on the causes he cared about, specifically Prohibition and Auburn's civic improvement. He ran for several offices on the Prohibition Party ticket, including governor in 1900 and Congress in 1908. Seen above, Eckhart is third from left holding the reins of the water wagon during a parade for the County Option Campaign that was held on November 26, 1909. That year, Eckhart also offered to build a public library on the condition that a Carnegie grant, the amount of which he felt was not enough, could be canceled. Carnegie withdrew, stating, "Let me congratulate Auburn upon having such a citizen as Mr. Eckhart." The library trustees then turned construction over to Charles Eckhart, who spent more than $40,000 on the building. (Top, courtesy of the William H. Willennar Genealogy Center; bottom, courtesy of Ellen England.)

Charles Eckhart

Charles Eckhart stands on the far right with two unidentified women while in California. As he aged, Eckhart and his family began to spend more time in the western states. While in Auburn on September 30, 1915, Eckhart's declining health worsened. His children, Frank, Will, and Anna, were all in California. Though they had been called for and had hoped to reach Auburn before his passing, the accounts of that time indicate that only his wife, his son Morris, and an attending physician surrounded him. His final gift to the Auburn community was the land for Eckhart Park. Unfortunately, it was not complete prior to his passing, but it has endured and has been enjoyed by countless individuals and families for generations since. (Courtesy of Ellen England.)

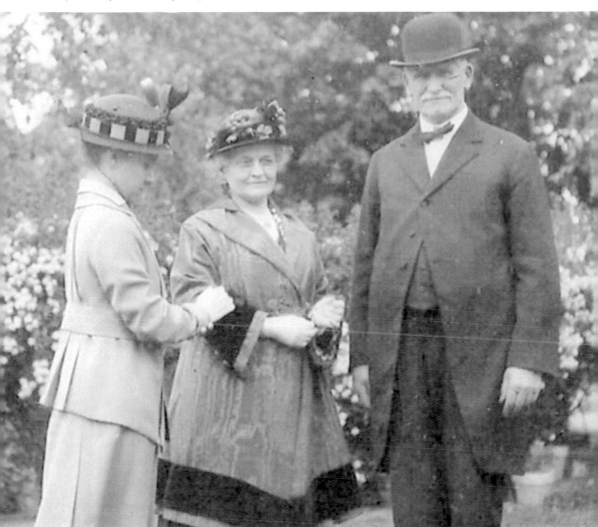

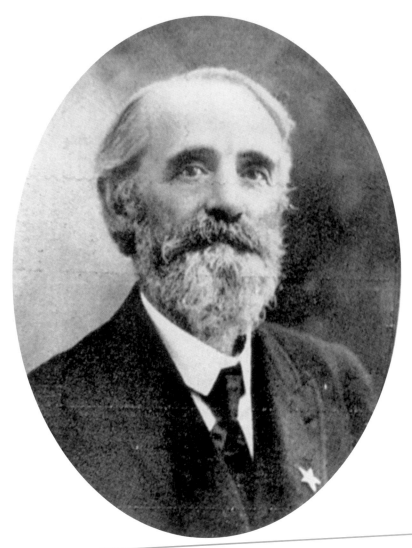

William H. McIntosh

Several veterans migrated to Auburn after the Civil War. One of them was William H. McIntosh, who became an important educator, historian, and benefactor. He was a teacher, soldier, historian, and civic-minded leader who gave much to the Auburn community. Upon his passing, he left a 1,000-page handwritten biography that detailed his humble beginnings as a child of Scottish immigrants and how their struggle with poverty influenced him. He struggled to get an education locally at Beloit Academy, where he trained to become a teacher. While stationed in Tennessee during the Civil War, he voluntarily organized a school for freedmen. Several Auburn women later arrived, and McIntosh fell in love with one of the teachers, Anna Cosper. Soon, an Army chaplain married them. They later moved to DeKalb County and lived the rest of their lives together. He was principal at Butler, and DeKalb County School superintendent, and as an expression of his love for Auburn, he gave his property to the community for use as a high school. His gift was accepted, and the old house on the property was torn down to make room for the new McIntosh building for use as a high school. McIntosh laid the first brick on July 2, 1916. After a delay in construction due to World War I, the building was finally dedicated on April 18, 1921, with McIntosh, who also bought all of the bonds that were offered for the construction, laying the last brick. (Courtesy of the William H. Willennar Genealogy Center.)

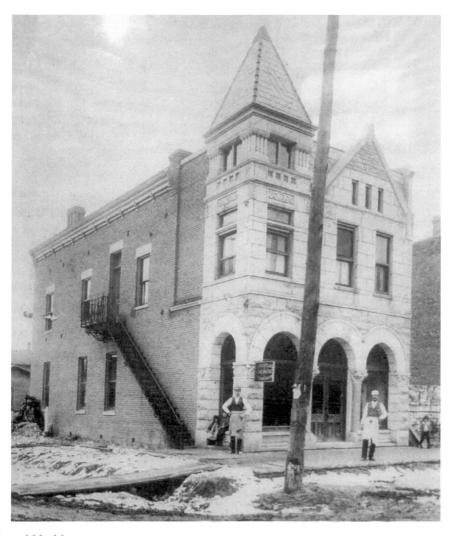

Smith and Madden

Walton Smith started a monument company in Churubusco and, later, established a similar operation in Auburn along with his business partner J.W. Ferguson. Later, Smith bought out Ferguson's shares of the business and brought his brother-in-law Alpheus Madden, the brother of Roxanne "Roxie" Madden, into the fold. Madden had an understanding of marketing well before its time, and to establish a showcase for the company, he led the construction of a building that would become known as the Smith and Madden Building, and later, simply the Madden Building. It was the first limestone building and the only Richardsonian-style building in the city, complete with a set of highly distinguished arches that served as a very visible example of their capabilities. Alpheus, a farmer by trade, took business classes in Fort Wayne and found himself as sole proprietor of the business following Smith's untimely passing around 1893. Madden brought his brothers Joseph and Charles on board and rebranded the business as the Madden Company, which was commonly referred to as "Madden Brothers." They also formed a monument business in nearby Butler, Indiana, and did work throughout all of northeast Indiana. The partnership later dissolved, with Alpheus keeping the Auburn business and Joseph and Charles maintaining the Butler unit. The Madden brothers later sold the Madden Building and formed a new monument company. In 1903, Alpheus built a new building on the corner of Seventh and Union Streets. That enterprise was sold from family hands in 1969 and renamed Tri-State Memorials. (Courtesy of John Bry.)

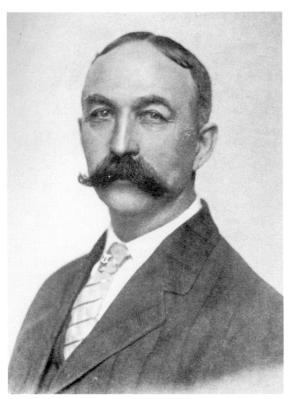

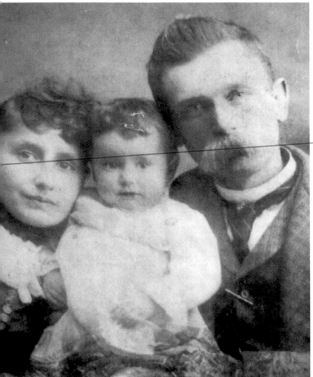

The Madden Brothers

Alpheus became auditor of DeKalb County and had involvement in the development and construction of the courthouse. Madden was a large property owner of an area known as Madden Field, where the community enjoyed circus events, air shows, and baseball games. Of the latter, Madden is said to have one day ordered the baseball bleachers to be disassembled because he considered the game to be a "passing fad." Pictured at left is Alpheus's brother Joseph, with his wife, Nellie, and their daughter Virginia, around 1902. The reasons for the Madden brothers' dissolution of their business may forever be limited to speculation, though they did reunite on projects throughout the years. Perhaps, the last project they worked on together was the Auburn Mausoleum, which is located at Woodlawn Cemetery and, later, came under the direction of John Bry, the great-great-grandson of Joseph Madden, the great-great-nephew of Charles Madden, and the great-great-great-nephew of both Alpheus Madden and Walton Smith. (Both, courtesy of John Bry.)

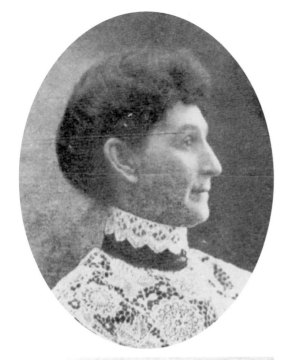

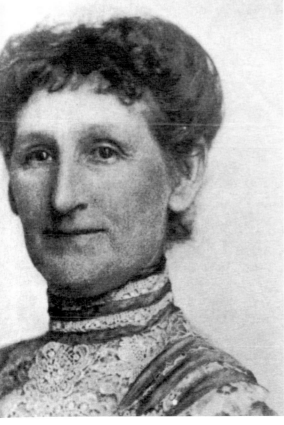

Dr. Lida Powers Leasure

Dr. Lida Powers Leasure was a strong-willed and scholarly woman whose ambitions set her apart from contemporaries and earned her an honorable reputation within her community and as a prominent figure in public service. Her work as an educator gave rise to her public notice and created a demand for her services wherever a high standard of professional excellence was required. She was a pioneering educator with advanced methods and a broad general knowledge base. She graduated from the Terre Haute Normal School at about age 20 and became a teacher in Marshall, Illinois, followed by Terre Haute and Indianapolis. In 1878, she came to Auburn, teaching several years in the high school and serving as superintendent of the city schools. In 1880, she taught in Princeton, Indiana, and married John H. Leasure of Auburn, which prompted her resignation and a return to Auburn. She was again a teacher at the high school in Auburn for a few years before taking up the practice of medicine. She attended and received her doctorate of medicine from the University of Michigan at Ann Arbor and began her practice in Auburn, which she later moved to Angola in 1892. The demands of her professional duties and her husband's business obligations in Auburn prompted another return to Auburn in 1903. Having given up her medical practice, Dr. Leasure resumed teaching and was principal of the Riley School for two years. In June 1911, she was elected to the position of county superintendent of schools, despite never truly being a candidate or campaigning for the position. In so giving her consent to the election requests from a number of the county's influential trustees, she earned the distinction of being the first woman elected to a public office in the state of Indiana. Personally, Dr. Leasure was known as a woman of many gracious qualities. She took a meaningful and valuable interest in the social, moral, and civic life of the community, supporting many movements for the benefit of the community. (Both, courtesy of the William H. Willennar Genealogy Center.)

Dr. Vesta Swartz (OPPOSITE PAGE)

Following his graduation from medical college in Cincinnati, Ohio, Dr. David Swartz came to Auburn. Two years later, he married Vesta Ward, the daughter of local merchant, Baptist minister, and Indiana state senator Stephen B. Ward. David enlisted in the 100th Indiana Regiment, serving the final two years of the Civil War as first lieutenant, assistant surgeon of the 5th Army Corps. Vesta also served as a teacher of Auburn schools and, later, enlisted in the Army, serving two years as a nurse. In 1882, she graduated from the Fort Wayne School of Medicine, becoming the first female practicing physician in the city and county. A brick home was built on Main and Sixth Streets to serve as both their home and office. (Courtesy of the William H. Willennar Genealogy Center.)

Dr. Bonnell Souder

Dr. Bonnell Souder was a pioneer of maternity care and x-ray equipment. Souder Hospital on Sixth Street was the first hospital in northern Indiana to offer maternity care and one of the first with fully equipped surgical rooms in the state, which was helped in large part by a grant from the Ford Foundation in the 1930s. She never married, but it was well known that she considered the babies who were born in her hospital to be her family and would often produce home movies of those children and their mothers as they returned for periodic examinations. In 1964, the hospital closed when DeKalb Memorial Hospital, which Dr. Bonnell actively assisted in forming, opened its doors. She served on its board of directors at the time of opening and donated much of her own equipment to the new hospital. Shown here is a group of ladies attending a social event; Souder is third from left. (Courtesy of William H. Willennar Genealogy Center.)

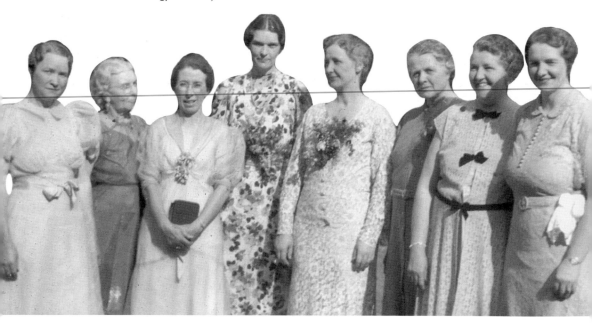

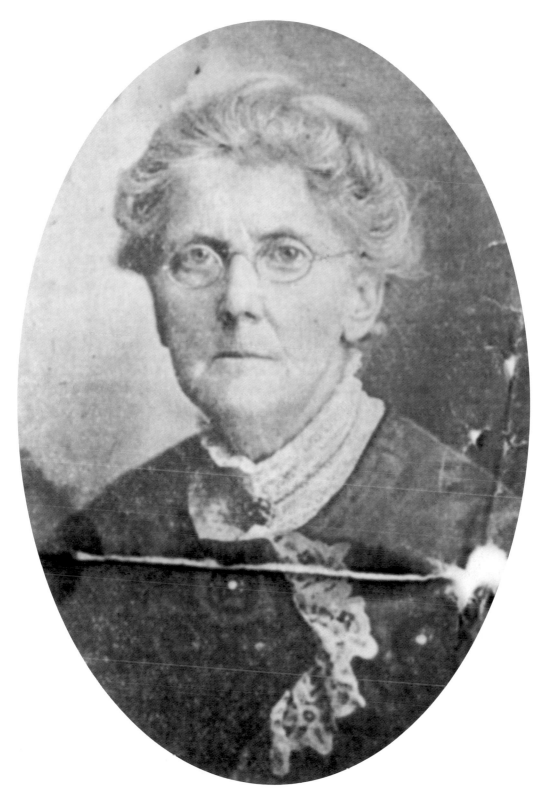

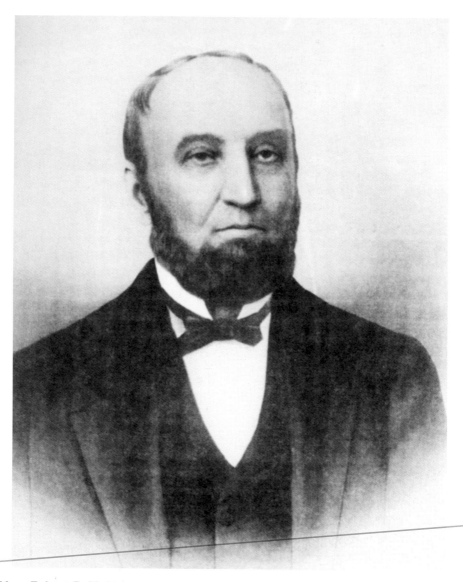

The Hon. Egbert B. Mott

At a young age, Egbert Mott's father died, leaving behind a family of five sons, three daughters, and a wife. The family moved to Pennsylvania a short while later in the year 1824. Egbert and his wife, Mary, were united in marriage six years later while living in Pennsylvania. In 1836, the Motts, along with their two children, moved from Pennsylvania to Ohio, living in a handful of counties before settling in Putnam County in May 1843. While there, Egbert and a lawyer, Morris, formed a strong friendship. They both moved to Indiana in search of a better place to practice their profession. Morris returned to Ohio, but Egbert permanently relocated to Auburn with his family on October 16, 1843, becoming the first lawyer to settle in the still young territory. In 1856, he was elected judge of the court of common pleas for the district, which was made up of DeKalb and Steuben Counties. Judge Mott was politically aligned as a Federalist, a Whig, and a Republican. According to the 1914 *History of DeKalb County*, he had "a remarkable memory, excellent judgment and the utmost firmness of principle. Throughout his whole life he was a faithful Christian, exemplifying his faith by a life of practical righteousness." He died on September 30, 1865, after an acute illness lasting three weeks. (Courtesy of the William H. Willennar Genealogy Center.)

Mary Mott

Mary W. (Wrigley) Mott lived to be 87 years old, passing away on October 4, 1893. During her earlier years, Mary had many literary and social advantages since her father was in partnership with Col. David Humphreys and Judge John Humphreys, who were manufacturers of fine woolen goods, broadcloth, and other items, in Seymour, Connecticut, which was then called Humphreysville. At an early age, Mary was placed in school at Derby, near Humphreysville, where she had the very best of social associations and education. While visiting her uncle, Abram Wrigley, of Luzerne County, Pennsylvania, she began teaching school, and at Providence, a few miles from her uncle's residence, she met her future husband, Egbert Mott. Of their two sons, Reginald Heber died as an infant, and Sheridan Edward was wounded at the Battle of Chickamauga in 1863 and died in a Nashville hospital about six months later. (Courtesy of the William H. Willennar Genealogy Center.)

Mott Family

Julie Mott Hodge was the daughter of Chester P. Hodge and Julia E. (Mott) Hodge. She was an Auburn High School graduate and an 1897 graduate of the University of Michigan. She taught school until 1912, when she became a Presbyterian missionary. Hodge spent 29 years as a missionary in the Philippines. She was one of more than 2,000 prisoners who were liberated by the US Army from a Japanese internment camp during World War II—a mere 30 minutes before what was believed to be their execution. She is buried along with approximately 20 other members of the Mott family in a private cemetery on the north side of Auburn just south of the former farm. (Author's collection.)

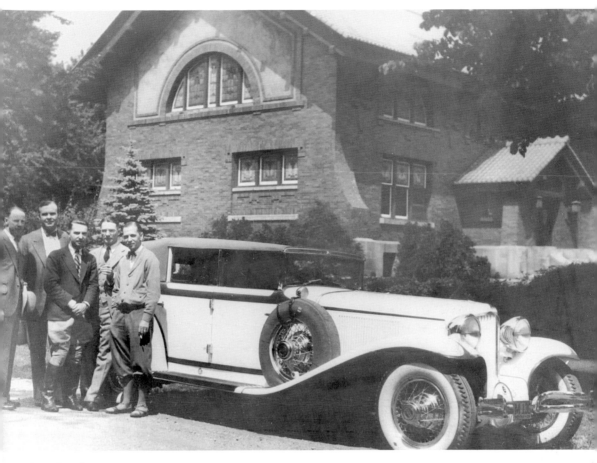

E.L. Cord

In California, E.L. Cord had three times lost $50,000 but was making a name for himself as the sales manager for Moon Automobile Agency in Chicago. That success enabled him to become the general manager of Auburn Automobile Company in 1924 and take no salary with the caveat that he could secure controlling interest in the company should he turn it around. Upon arrival in Auburn, he ordered the stagnant inventory be repainted with new trim and accessories. That inventory was quickly no more. The following year, he introduced eight-cylinder cars and two-toned color schemes. Sales increased and, by 1926, Cord was president of the company. The next year, he began racing the Auburn, breaking all stock car speed records from 5 to 5,000 miles at the Atlantic City Speedway. Also in innovating fashion, Cord changed the manner in which Auburn dealerships operated by transitioning them from small, independent garages into a network of full-line dealerships while adding an export division that was headed by R.S. Wiley. In 1929, he began acquiring other companies, including Duesenberg Motors. That year, Cord also oversaw the introduction of the first production front-wheel-drive automobile, the Cord L-29, engineered by Herb Snow and styled by Al Leamy. He left the company in 1932. In this photograph, Cord is on the far right. (Courtesy of the William H. Willennar Genealogy Center.)

Glenn Pray

In 1960, a Tulsa, Oklahoma, schoolteacher named Glenn Pray became the youngest president of an American automobile company when he purchased the remains of the Auburn Cord Duesenberg Company from a businessman who specialized in buying bankrupt manufacturing and automobile companies. In the years to follow, Pray resurrected the Auburn and Cord monikers while creating modernized versions of the legendary cars. His attention to detail combined with his genius for design and engineering his replica Auburn and Cord automobiles made them highly sought after by collectors and enthusiasts around the world. He remained active in the Auburn and Cord enthusiast circles through the remainder of his life. Upon his passing, he was remembered fondly as a visionary, inventor, innovator, entrepreneur, motivational speaker, aviator, automobile enthusiast, loving father, and friend to all. At his death, Pray was still the owner of the Auburn Cord Duesenberg Company and the rights to the Cord name. His life is chronicled in two books: *Glenn Pray, The Man Who Brought Legends to Life* by Josh B. Malks and *Glenn Pray, The Untold Stories* by Glenn Pray, as told to Cyndie Gardner. (Courtesy of David Turner.)

William H. Willennar

Born October 10, 1875, in Steuben County, William H. Willennar worked briefly for the Auburn Automobile Company. In 1910, he organized the Double Fabric Tire Company along with A.L. Murray. It was the forerunner to the company better known as Auburn Rubber Company. He served as president of the Auburn State Bank until 1942 and then was chairman of the board until his death on September 2, 1961. Throughout his life, he was interested in many civic and charitable organizations in Auburn and was active in politics. He was the largest single contributor to the development of the DeKalb Memorial Hospital at the time of fundraising for the original building. A foundation was formed after his death, which has contributed generously to the Auburn community since his passing, donating over $5 million to date. Eckhart Public Library has been one of the major beneficiaries of the foundation. The foundation's funds helped make possible the expansion and renovation of the library in 1996, including restoration of the fountain and park. A state-of-the-art genealogy center proudly bearing his name was paid for exclusively by the Willennar Foundation, which has also donated generously to the Auburn Cord Duesenberg Museum and the Auburn Community Band. (Right, courtesy of the William H. Willennar Genealogy Center; below, author's collection.)

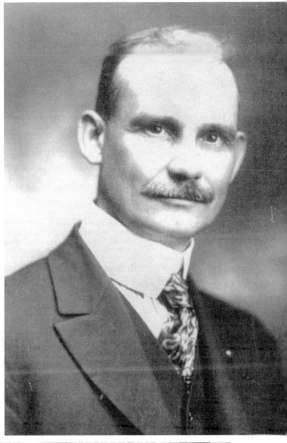

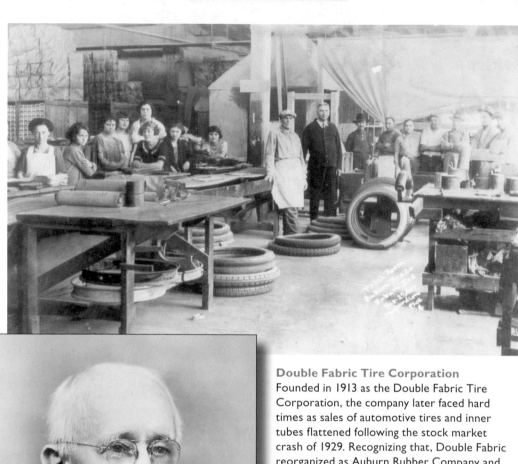

Double Fabric Tire Corporation
Founded in 1913 as the Double Fabric Tire Corporation, the company later faced hard times as sales of automotive tires and inner tubes flattened following the stock market crash of 1929. Recognizing that, Double Fabric reorganized as Auburn Rubber Company and sought out a new niche. As principal stockholder, A.L. Murray (left) brought a lead soldier home from England with the intent of using it to mold toy soldiers made of rubber. Edward McCandlish, a freelance artist, designed and decorated samples of the rubber soldiers, which were accepted enthusiastically by toy buyers. Auburn Rubber began toy production in 1935 with a squad of five soldiers.

Walter Ball (1902–1965) returned from World War I and began to work for Kunkle Valve in Fort Wayne, Indiana. Soon after, he started his first foundry, W.H. Ball Castings, in Garrett, Indiana, with his business partner Al Barr in the late 1920s. The foundry closed in the late 1930s, and Walter went to work for the Double Fabric Tire Company. The photograph above shows several workers inside the factory around 1932. Walter is the younger man standing in the middle. (Above, courtesy of Jennifer Fahlsing and the Ball family; left, courtesy of the William H. Willennar Genealogy Center.)

CHAPTER TWO

Leaders of Business and Industry

This is the hour of realization. It is a tribute to an accomplishment of free men working together.
—Hal G. Hoham

A movement to develop a new hospital to serve all of DeKalb County began in the 1950s and gathered steam in the years that followed, eventually becoming known as the "miracle of Indiana" because of local donors contributing $2.5 million to build it on Auburn's east side.

Hal G. Hoham was mayor of Auburn at the time the endeavor first began. One can almost imagine the pride in his voice and the smiles on the faces of all in attendance as he praised the leadership and effort of Auburn's devoted citizenry and business leaders. A great deal of that tribute was no doubt directed toward the guiding influence of Glenn T. Rieke, who served as president of the committee that nurtured the dream into the "miracle" it became.

It is a standout story among many similar narratives. Committed business leaders achieve monetary success and then use their given skills, experience, and connections to lead selfless efforts that bring progress and betterment to their community. Rarely, if ever, does one man or woman do so alone, however. Likewise, rarely, if ever, are those "miracles"—whether big like the hospital, public library, or YMCA, or small like a charity run or raffle—accomplished without challenges. The men and women represented in this chapter faced challenges, and they most certainly had help along the way.

But what sets them apart and distinguishes them as legendary locals is their fortitude and willing spirit to challenge what is commonly accepted. It is about B.O. Fink rebuilding the Auburn Foundry from ashes not once, but twice, within near impossible time frames. It is about E.L. Cord overhauling a suffering automobile company and making history in the process. It is about W.H. McIntyre having the vision to realize the potential of many different fields of endeavor.

It is about a spirit to prevail no matter how difficult the challenges that may lie ahead.

John L. Davis

John L. Davis had a heavy influence in the promotion of public enterprises and utilities and served as a catalyst for progress in Auburn and DeKalb County. Upon his passing, his name was deeply engraved on the history of both. He was widely recognized as a respected citizen of strong character, integrity, and honesty. Known to be generous, Davis had a long career while also serving as a faithful and loving husband and father. Born on November 3, 1834, at Black Rock (Buffalo), New York, he journeyed to Wabash, Indiana, in 1853 where his brothers William and Lewis operated a hardware business. He returned to New York during the following year and married Louisa Hauenstein in 1856. They tried their hand at farming in Aurora New York for the next six years before coming to Auburn in 1862. At the time, his brother Joseph D. Davis was owner of the Pioneer Hardware Store and was in failing health. Joseph had asked that John come run the business before his passing in April 1865. Davis became the successor to the hardware business, located on the corner of Main and Eighth Streets. It burned down a couple years later. Davis rebuilt, and it has been run continuously as a hardware store ever since. Davis enjoyed a large and profitable business through the years and became known as one of the most successful businessmen in the community. In 1873 or 1874, he took an active role in efforts to advance the city's interests through giving of money and support for the construction of the railroads. He assisted in bringing natural gas to Auburn, and although it lasted only about two years, it cultivated much public spirit. Around 1890, he worked to establish a county fair in Auburn and also contributed to starting several factories and other businesses. Davis later began buying real estate in Garrett, opening a hardware store and a bank there, while, at the same time, operating a hardware store and bank in Auburn. His expansion to Garrett also brought the first telephone services to Auburn. In 1886, Davis sought to connect his Pioneer Hardware in Auburn with his Pioneer Hardware in Garrett. The connection was a line for his private use, but he allowed others to communicate between the two towns. He was elected county treasurer in 1886 and remained in the position for three and a half years. One of his four children, Fred, served as deputy county treasurer. After leaving public office, he returned fully to his business interests until the panic of 1893, when he suffered great business loss. He reestablished his hardware business and put it on a strong financial state before becoming ill and passing away August 14, 1900. (Courtesy of the William H. Willennar Genealogy Center.)

Mayor Hugh Culbertson

Hugh Culbertson was an energetic and well-known businessman known for progressive methods while being a contributor to the commercial advancement of Auburn. He was born on April 9, 1853, to Robert and Margaret (Robinson) Culbertson as one of seven children. During boyhood and early adulthood, he tended to the family farm. In 1875, he married Harriett, the adopted daughter of James Dragoo, a pioneering settler of DeKalb County who took on a prominent role in the civic life of the community. He began farming on his own and did so until 1881, when he went to Columbia City to work in the implement and buggy business. Later that year, he came to Auburn and bought an interest in a hardware store. Several years and several transactions later, Culbertson became the principal stockholder, and the Culbertson Hardware Company was incorporated. His business success was the result of persistence and honest effort, characterized by the strict integrity that earned the admiration of the community. Politically, he aligned with the Republican party, serving as a delegate to state conventions multiple times and as an alternate delegate to the 1908 National Convention where William Howard Taft was nominated for the US presidency. In the fall of 1909, he was elected mayor of Auburn following a heavily contested election. A special election had to be called after the general election resulted in a tie vote between the two candidates. Culbertson was elected and served as mayor until 1914. During his administration, a new city hall was built. The contractor was H.H. Achemire of Auburn. It also housed the Auburn Fire Department and included living space for full-time firemen. (Courtesy of the William H. Willennar Genealogy Center.)

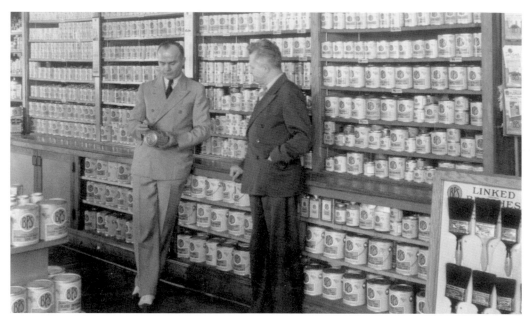

Ed Kokenge

This is a photograph of Ed Kokenge and William Cooper, the owners of Auburn City Hardware, which they purchased in 1932. Kokenge purchased Cooper's interest in the business in 1939 and renamed it Auburn City Hardware. Ed passed away in 1979. Ownership was transferred to his son Robert "Bob" E. Kokenge, who had joined the business in 1954. Shown below, Bob is handling parts for customer Hugh Provines. This workbench is located in the basement of the store. (Both, courtesy of the William H. Willennar Genealogy Center.)

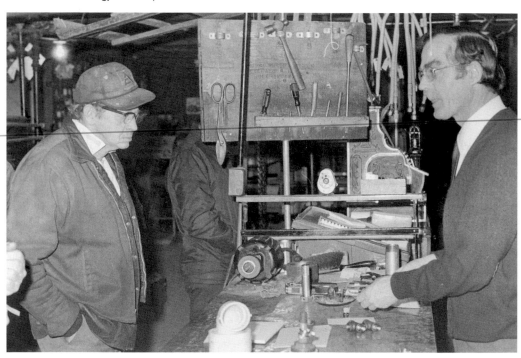

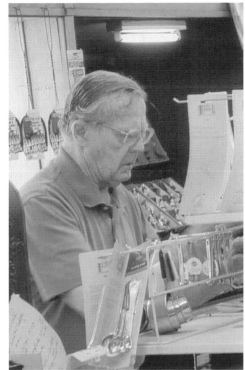

Kokenge Family
Robert "Bob" E. Kokenge (right) had joined the
business in 1954 and took on ownership in 1979. In
1982, Bob's son, Robert "Bob" A. Kokenge (below)
joined the business and has been involved in running
it since. As of this writing, the building still housed a
hardware store, and both Bob E. and Bob A. could
be found tending to the store and their customers
daily. (Both, author's collection.)

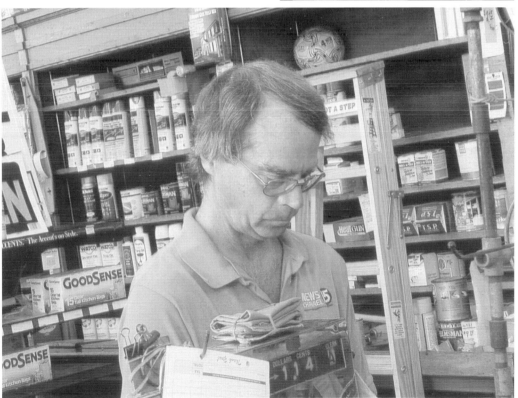

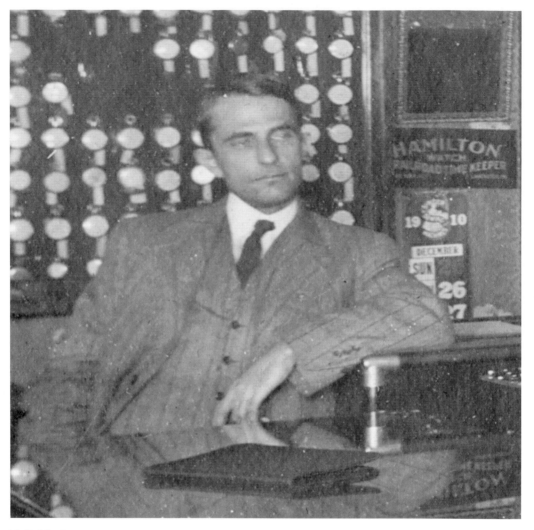

E.O. Little

Edward O. Little was born in Auburn on March 1, 1879. His father, Henry E. Little, learned the printing trade and joined the *Auburn Courier*, of which he became foreman under the ownership of James Barnes. Edward's mother, Sylvia (Orr) Little, was the daughter of Edward and Rachel (Updike) Orr and was descended from nobility in Holland. During the five years after high school, Edward served an apprenticeship under the direction of Auburn jeweler D.A. Hodge. Edward Little then started a small business on his own in Garrett. A mere nine months later, he moved to Auburn, opening a store in a small frame building on Main Street between Seventh and Eighth Streets. Success followed, and he relocated his store to the north side of Seventh Street, just west of Main Street, a short time later. That location has housed a jewelry business ever since. Edward Little was a Democrat in politics and, at one time, held the distinction of being the longest serving elected official in the history of Auburn, having been elected city clerk in 1904 and being reelected multiple times thereafter. Fraternally, he was a member of the Knights of Pythias as well as the Masonic order. Little also was known to be a supporter of youth athletics and was the little league coach of professional baseball player Rollie Zeider. In addition, Little was involved in the formation of the Auburn Businessmen's Association. (Courtesy of Mike Littlejohn.)

Little Jewelry Store

In 1915, as a high school student, Charles Carbaugh began working for Edward O. Little at his Auburn jewelry store. In the 1950s, Carbaugh joined Little as a business partner and assumed sole ownership through Little's estate following Little's passing in the mid-1950s. He carried the Little Jewelry Store name for a few more years, changing it in 1960 to Carbaugh Jewelry, as it is presently known. (Both, courtesy of Mike Littlejohn.)

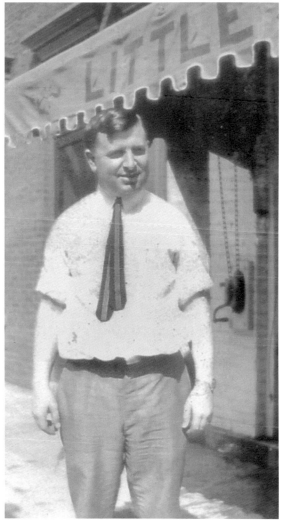

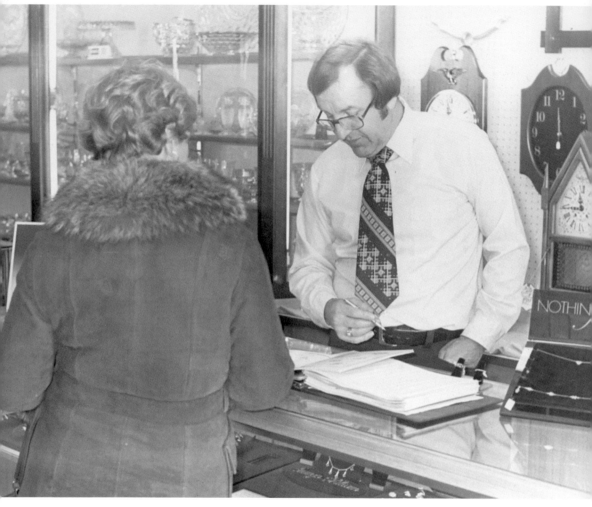

Carbaugh Jewelry
In 1962, Charles passed on, and his son Robert "Bob" Carbaugh purchased the store through Charles's estate. Bob and his wife, Betty, worked side by side day in and day out for approximately the next 35 years. (Courtesy of Mike Littlejohn.)

Bob and Betty Carbaugh
It is said that Bob and Betty Carbaugh had a remarkable ability for being able to work closely together on a daily basis and then go home and still carry on a typical marriage that separated work from the other aspects of life. (Courtesy of Mike Littlejohn.)

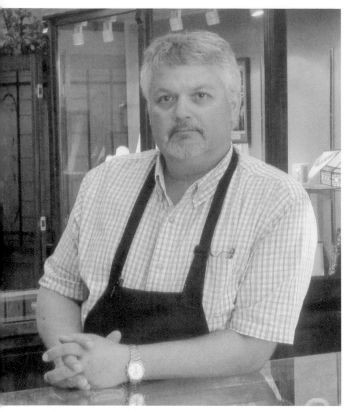

Mike Littlejohn
In 1980, high school student Mike Littlejohn came into the Carbaugh Jewelry store seeking assistance on a report for his vocational metals class. Bob asked Mike if he would like to try his hand at engraving and, later, offered Littlejohn a job that served as an unofficial apprenticeship. In 1997, as Bob and Betty Carbaugh moved into semiretirement, Littlejohn purchased the store, though he continues to maintain the Carbaugh Jeweler's name. Littlejohn also is a longtime president of the Downtown Auburn Business Association (DABA), a role he began serving in from 1998. At the time of this publication, DABA membership has grown from 16 to 85 under his tenure. (Both, author's collection.)

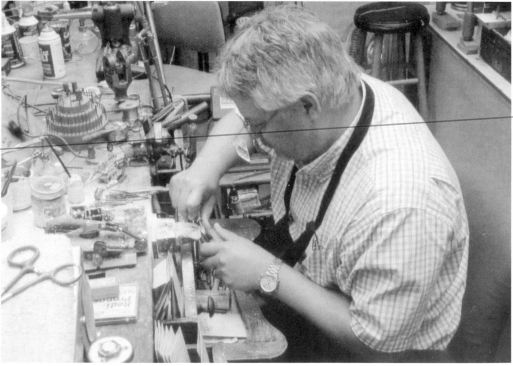

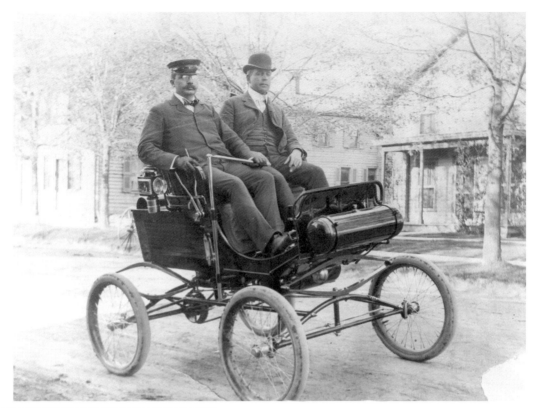

The McIntyres of Auburn

In 1887, W.H. Kiblinger founded his namesake company to build buggies. After his passing, the company was purchased by W.H. McIntyre and S.C. Snyder in 1894. In 1901, McIntyre purchased Snyder's interest. As early as 1897, McIntyre started experimenting with automobiles and may have built the first operational cars in DeKalb County. In 1906, McIntyre began building cars commercially and made his first prototypes available in 1907. McIntyre's brilliance came through his recognition that the market sought inexpensive yet durable vehicles. Demand grew so strongly that the company, employing 400 men across multiple plants, had trouble keeping up. As a man of foresight and vision, he appreciated and recognized the potential of diverse endeavors. His experience allowed him to establish electrical utilities in Butler, Waterloo, and Garrett while being instrumental in the exploration of and development of natural gas in Auburn. Pictured above, W.H. McIntyre is being chauffeured by Harry C. Henry. At left, Harry McIntyre is shown in a 1909 yearbook photograph. The caption read: "This is Harry so solemn and grave. Tho' he looks cowardly, he really is brave: Thru' Dutch you ought to see him go, for thru' all the hard passages, he lightly doth go." (Both, courtesy of the William H. Willennar Genealogy Center.)

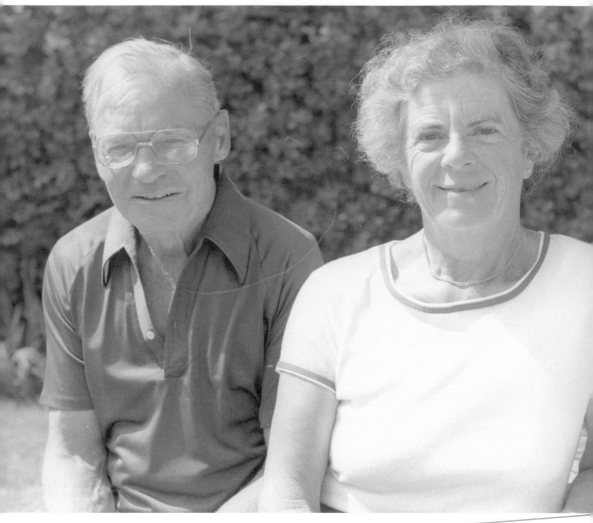

Glenn T. Rieke

Fort Wayne machinist Theodore Rieke is widely considered to have revolutionized the steel drum industry by creating a flange closure that was inserted without brazing, required no fusing of metals, was easily replaceable, and did not create excessive scrap. He seized an opportunity to grow his business and began seeking manufacturing space that would be less costly than the Chicago market. Wooed by the Auburn Commercial Club, the business relocated to Auburn in 1923. With the business, Auburn also gained one of its most generous and capable citizens in his son, Glenn T. Rieke, who was just approaching his teenage years. A graduate of Auburn High School and Purdue University, he studied civil engineering with an aim to be a bridge builder. While he did not make building physical bridges his life's work, mainly due to the Depression-era economy, Rieke built numerous metaphorical bridges throughout his lifetime residency as one of Auburn's own. He assumed the presidency of the Auburn-based Rieke Corporation in 1947 and was chairman of the board from 1965 until his retirement in 1978. For most, those accomplishments would tell a sufficient story, but Glenn Rieke's story is much larger. He also was a board member of City National Bank and Lincoln National Bank, a director of the Indiana Manufacturers Association, and a trustee of Tri-State University. He not only served as president of the YMCA, but also was instrumental in establishing it. In addition, he led the community drive to build the new DeKalb Memorial Hospital in 1962. (Courtesy of the William H. Willennar Genealogy Center.)

Rieke Corporation
Members of the Rieke bowling team are, from left to right, Irvin Rieke, Glenn Rieke, Cal Groscup, Jack Kelly, Theo Teeders, Garth Silberg (a freight hauler for Rieke), and Bill Fitzsimmons, the pilot of the Lockheed airplane that is pictured. Davis Studio took this photograph in 1940. Through the Rieke family's interest in flying, the company became one of the first northeast Indiana companies to make regular use of airplanes for business travel. The US government asked to use this Rieke Metal Products–owned plane; during World War II, only five companies were asked this by the government. A year and a half later, the company received a check for the listed depreciated value, which was just over $30,000. After Auburn Automobile Company closed in 1937, the Auburn Airport entered bankruptcy court. Glenn Rieke purchased it and saved it from closure in 1940. Residential sprawl later neared the airport boundaries, and as the size and power of airplanes increased, it became difficult for them to get airborne, so the Auburn Airport in that location closed in 1964. In 1994, Rieke donated the land to the city, stipulating that the 63 acres be turned into a park. Today, the land is a multiuse facility with a pond, pavilion, and several ball diamonds. (Courtesy of the William H. Willennar Genealogy Center.)

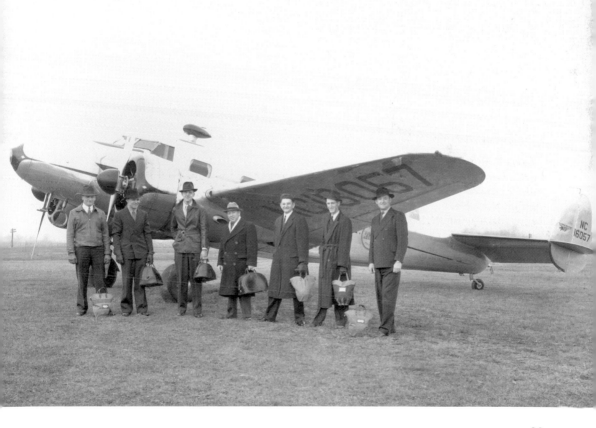

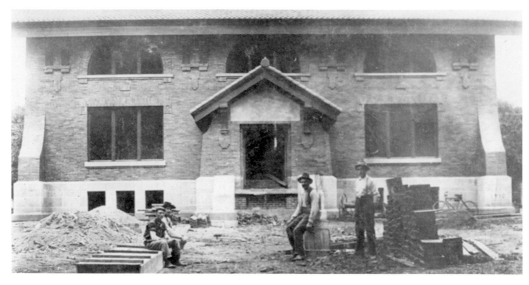

J. Perry Long

In the photograph above, the historic Eckhart Public Library is under construction. The man seated in the center is J. Perry Long, who was selected to be the contractor. Long enjoyed a successful career and reputation as an Auburn building contractor, which he took up at age 21 after having worked his family's farm. He became known as one of the leading contractors of DeKalb County, constructing many well-known residences and business buildings in the community. His work was characterized by high attention to detail and reliability. In 1904, he was elected a member of the city council and served also as a firefighter. Long was also affiliated with the Knights of Pythias as well as the Knights of the Maccabees. Long is pictured below on the left with two fellow workers. (Above, courtesy of the William H. Willennar Genealogy Center; below, courtesy of Ellen England.)

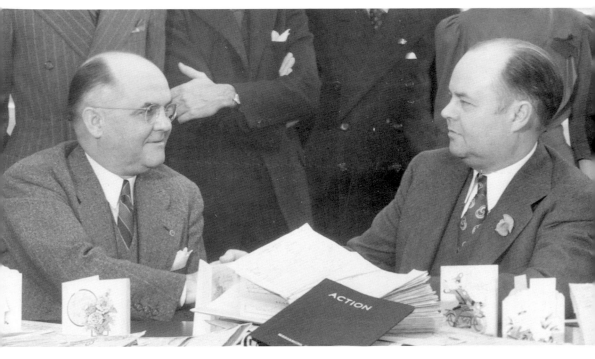

Frank Messenger

In 1913, at the age of 61, Frank M. Messenger needed to provide income for his family following a 10-year span of religious studies and a ministry that had him taking no salary. In response, he put his prior business and manufacturing experience to use and began producing sacred art calendars. It marked the beginning of Messenger Publishing Company, which has now celebrated more than a century of business. Founded in Chicago, Messenger borrowed $3,000 to promote and sell scripture calendars with the help of his son Harry. By 1927, the company was supporting national campaigns. In the 1930s, Messenger acquired the Auburn Greeting Card Company and relocated to a facility east of downtown Auburn. It was during this time that many reported that Messenger was the owner of the largest collection of original religious art in the world. Frank Messenger's original mission of bringing the word of Christ through print continues to this day. (Courtesy of the William H. Willennar Genealogy Center.)

Donald Schaab and the Schaab Family

The Schaab family and various partners operated one of the longest running (from 1877 to 1975) commercial businesses in Auburn history, known best as Schaab's Department Store. The store began in the 1870s as a grocer and seller of dry goods. Under the direction of C.A. Schaab, president; and G.E. Beugnot, vice president, the enterprise grew into one of the most well-known department stores around. In the 1950s, Donald Schaab, who is pictured here, acquired all shares of stock in the company after beginning as a clerk in 1911 and becoming a partner in 1914. (Right, courtesy of the William H. Willennar Genealogy Center; below, author's collection.)

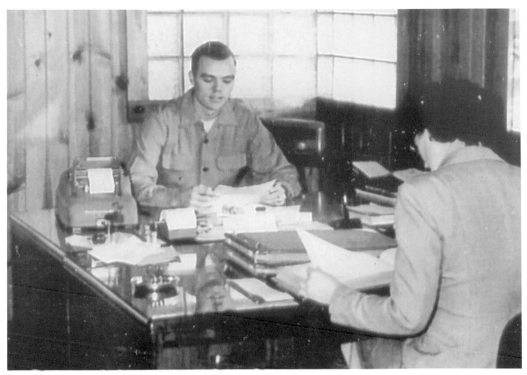

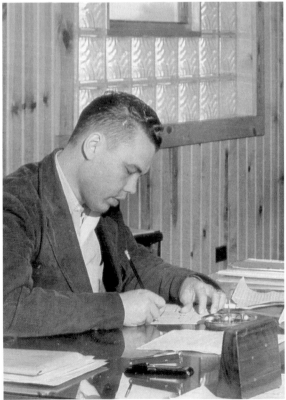

Ronald and Robert Ball
Seen above on the left is Ronald Ball while at the Ball Brass and Aluminum Foundry Offices in 1949. Ronald joined the Army in 1952. During the Korean War, he was stationed in Germany with the occupation forces. After military service, he returned in 1949 to work in the foundry as a business partner. Pictured below is Robert Ball at the Ball Brass Offices in 1948. Robert also saw military service and returned to partner in the business. He was a member of the board of directors at Peoples Federal Savings Bank of Auburn, a president of the DeKalb County School Board, and a member of the Auburn Lions Club. (Both, courtesy of Jennifer Fahlsing.)

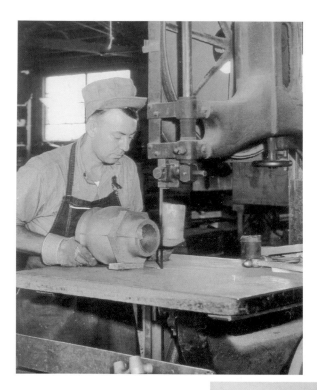

Fred Ball
Pictured is Fred Ball doing a cut off while on the floor at the Ball Brass and Aluminum Foundry during the 1940s. (Courtesy of Jennifer Fahlsing.)

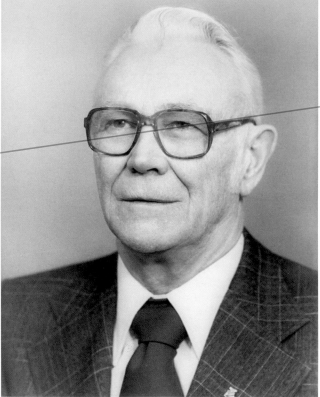

Kenneth "Kenny" Ball
Kenneth "Kenny" Ball, born on January 6, 1932, was the son of Walter and Elsia Ball. He had two brothers, Robert and Ronald, and a sister, Mary Ann. Ball was a partner at Ball Brass and Aluminum Foundry, retiring in 1984. A US Army veteran of the Korean Conflict, Kenny was also a member of the Trinity Lutheran Church. He passed away in 1995. (Courtesy of the William H. Willennar Genealogy Center.)

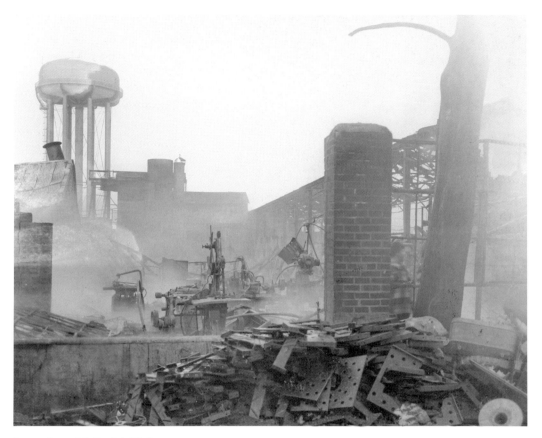

Burr Oswald (B.O.) Fink

Burr Oswald (B.O.) Fink built the once thriving Auburn Foundry from practically nothing. In the process, he became recognized as a community leader and father-like advisor to other area business professionals. He was born August 2, 1001, to a family of blacksmiths. As a teenager, his father, Alexander Willey Fink, bought a defunct sawmill and timber with plans to build a lumber business. The elder Fink fell ill, and young B.O. was forced to take over. The venture failed, but he took away valuable experience in leading others. While at Purdue University, he was voted 1909 senior president and then graduated with a degree in mechanical engineering. A year or two after graduating, he joined Indiana Fuel & Light to manage the company's Auburn Junction plant, which extracted "artificial gas" from coal. In 1912, B.O. leased what remained of the struggling Auburn Foundry Co. and put his lessons to work. As he righted the ship, fire destroyed the foundry in 1916. B.O. assembled the workers to clean the site and poured a new foundation five days later. Less than two weeks after the fire, production resumed. During America's involvement in World War I, the Auburn Foundry grew by making tracks for tanks, purchasing additional property eight times during a span of one and a half years. At first, B.O. regularly worked alongside his men on the floor. As business grew, he focused on administration but did not hesitate to roll up his sleeves and pitch in as needed. B.O. later began handing off duties to his son Dick Fink, as he moved toward retirement, which was abruptly put on hold in 1951 when another devastating fire consumed the plant. Father and son threw themselves into reconstruction and reopened more than three months earlier than even the most optimistic of persons projected. After rebuilding, B.O. resumed retirement, passing away at his family's Spring Harbor, Michigan, home on August 27, 1954. (Courtesy of the William H. Willennar Genealogy Center.)

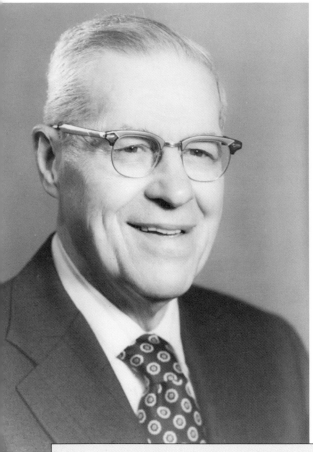

Harold Gengnagel

Harold Gengnagel began his career in 1925 with a grain business that operated elevators in Helmer and Spencerville. In 1934, he formed Gengnagel Coal Company and, in 1950, Gengnagel Fuel Company. At its annual convention in 1961, the Indiana Fuel Merchants Association elected him president and then reelected him the following year. In 1974, he shifted his career from the fuel industry to lumber, opening Gengnagel Lumber Company. Gengnagel passed away in June 1984. The gas station below is the Craig Gulf Station, which was located at 701 West Seventh Street. Gengnagel acquired it in 1967 and operated it as company president until 1972. (Both, courtesy of the William H. Willennar Genealogy Center.)

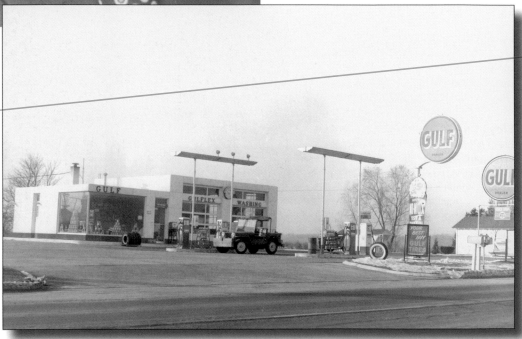

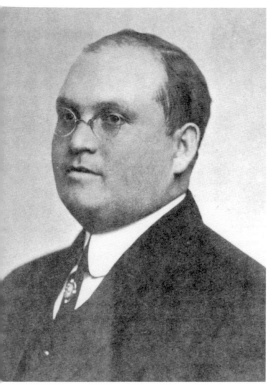

Raymond C. Dilgard
Widely known as an honored lifelong citizen of Auburn, Raymond C. Dilgard was a successful furniture dealer and undertaker. He was raised on his father's farm until age 16, when he graduated from high school in Waterloo in 1899. He then was a student at the Tri-State Normal School in Angola and went on to become a traveling salesman for the International Harvester Company. A year later, he took on the same role with T.G. Northwall & Company. Tiring of the road, Dilgard learned embalming in Chicago and formed a business partnership with Ben K. Adams, an undertaker and furniture dealer. The following year, Dilgard bought his partner's interest and continued on as sole proprietor. Known to have an agreeable disposition and strong business qualities, Dilgard was a well-liked man of Auburn. He and his wife, Katherine Smith, were members of the Methodist Episcopal church. (Courtesy of the William H. Willennar Genealogy Center.)

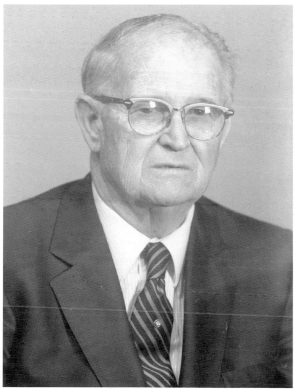

Lloyd Cline
Lloyd Cline was born in LaGrange on September 7, 1913. His family owned Dilgard and Cline Funeral Home in Auburn. Lloyd and his wife, Helena, retired in 1986 and sold the business to D.O. McComb & Sons, which also had a funeral home in Auburn. Lloyd served on the board of directors for DeKalb Memorial Hospital and Peoples Federal Savings and Loan. Lloyd passed away on November 18, 2003, at the age of 90. (Courtesy of the William H. Willennar Genealogy Center.)

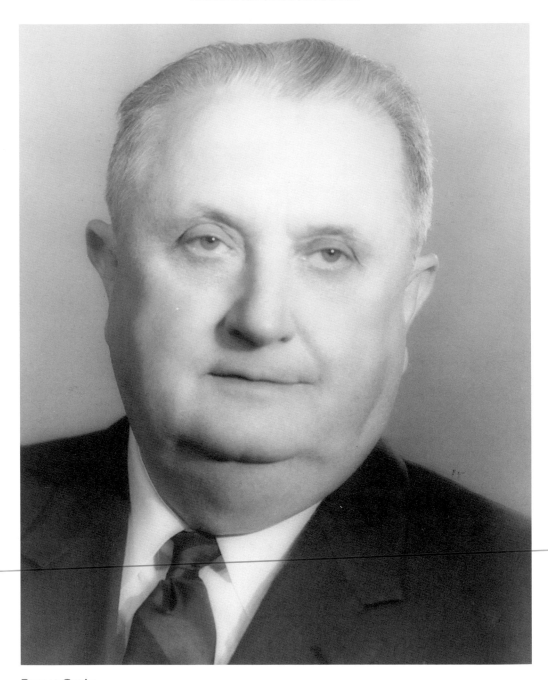

Forest Gerig
For 50 years, Forest Gerig owned and operated Gerig Furniture Store and Gerig Funeral Home. In the 1930s, he and Ford Ferguson owned Electric Sales & Service at 112 North Main Street, which was the location of Eckhart's Jewelry Store from 1959 to 2002. He served as chairman of the board at Peoples Federal Savings and Loan Association, was a 48-year member of the Auburn Lions Club, a board member of the Auburn YMCA, and had membership at the Auburn Elks, Moose, Knights of Pythias, and Odd Fellows. He was a member of the DeKalb Memorial Hospital Foundation and was instrumental in raising funds to build the hospital. (Courtesy of the William H. Willennar Genealogy Center.)

Harvey Penland
In this photograph, local business owner Harvey Penland leans with his arms folded against a cluttered work area. "Harv" was the owner of Penland Auto Parts, which was located on County Road 11A. He also became the owner of the Sunshine Market on East Seventh Street, which many longtime Auburn residents remember as Grogg's, having previously been owned by Edward W. Grogg and Alva S. Grogg Jr. Roberta Andres took this photograph in August 1979. (Courtesy of the William H. Willennar Genealogy Center.)

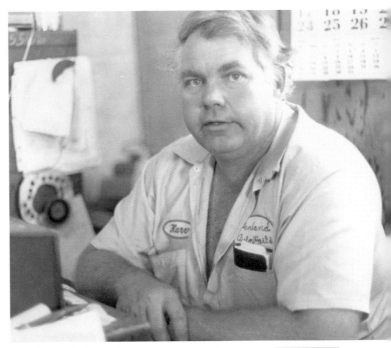

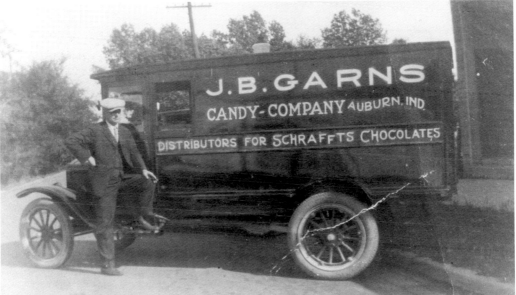

John (J.B.) Garns
John B. Garns was a distributor of candy and later expanded to include other food items. His company was headquartered in Auburn on Union Street between Fifteenth and Sixteenth Streets near the DeKalb County Fairgrounds. In August 1978, the facilities of the Garns Company were completely destroyed by fire. John Garns and several employees then joined F. McConnell & Sons of downtown Decatur. The newly acquired expertise enabled F. McConnell & Sons to expand its product offerings, and approximately two years later, the company relocated to a much larger facility in New Haven. (Courtesy of the William H. Willennar Genealogy Center.)

Blaine (B.O.) Snepp

Blaine (B.O.) worked for the Auburn Automobile Company for several years and served as board president of Auburn schools, where his financial and executive experience proved to be a strong asset. (Courtesy of the William H. Willennar Genealogy Center.)

Robert Wiley

As E.L. Cord began building up a network of full-line dealers to boost sales, Robert S. Wiley was chosen to head up an export division of Auburn Automobile Company. It resulted in many cars being shipped throughout the world, with dealers in 93 countries. Wiley would visit personally with prospective partners in many of the countries. Vehicles would be partially disassembled before getting shipped in wooden crates. This photograph is of the James H. McIntyre and Joyce E. Wiley wedding on September 14, 1946. Joyce was the daughter of Robert Wiley and Lois Dolan. James was the son of Harry C. McIntyre and Harriette L. Casey. (Courtesy of the William H. Willennar Genealogy Center.)

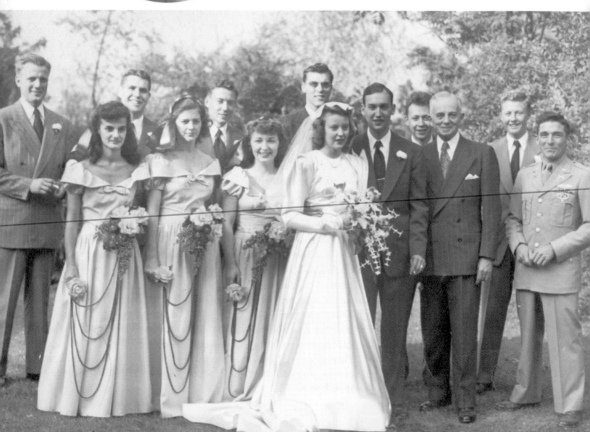

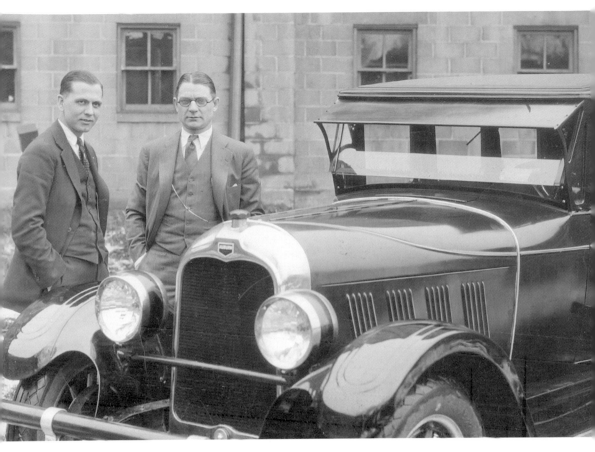

Roy H. Faulker

As a boy, Roy H. Faulker (right) played in the streets of Allegheny, Pennsylvania. As a young adult, he was clerk for the controller's office in Pittsburgh. And then, he started selling cars. Faulkner was president of the Auburn Automobile Company during the creation of the Cord 810 and was a close friend of E.L. Cord (left). When the Chicago investment banking firm F.B. Hitchcock and Company purchased the Auburn Automobile Company, it hired Faulkner, who was a Frank Santry Motor Company salesman, to become sales manager. Despite his innovative advertising, the conservatively styled Auburns remained on the lots of their modest network of dealers. E.L. Cord appointed him vice president in 1931, but Faulker left somewhat mysteriously nine months later for a top position at Studebaker Sales Corporation and Pierce-Arrow Motor Company. He was rehired by Cord again in 1934 and appointed president. There are some who believe that the Pierce-Arrow sojourn was an attempt by Cord to take over Pierce from the inside. Upon his becoming president of the Auburn Automobile Company, he returned home to Pennsylvania and was revered as a classic "Hometown Boy Makes Good" story. The *Pittsburgh Press*, lauding his achievements, wrote that Faulkner was "tall and ruddy . . . like a young college professor with an ease of manner and a clicking personality that seems to make people want to buy autos rather than Faulkner's selling them." Following his departure from the Auburn Auto Company, he ran Roy H. Faulkner and Associates in Auburn. While assisting Joe Knapp in the creation of the Auburn Cord Duesenberg (ACD) Club's first national reunion, Faulkner died suddenly on August 15, 1956. (Courtesy of the Auburn Cord Duesenberg Automobile Museum.)

Dean Kruse

Having established an auctioneering career before leaving high school, Dean Kruse was selected for Boys State, sparking an active interest in politics from then on. He was the president of his high school class and became the Republican party precinct committeeman and then county chairman before serving as a state senator from 1966 to 1970. Upon his election as state senator at age 25, he was among the youngest in the history of the state to earn such a distinction. In 1971, as organizers in Auburn sought to raise money for a celebration of its automotive history, the idea of auctioning classic Auburns, Cords, and Duesenbergs that were built by Auburn Automobile Company led to the establishment of what has become known worldwide as one of the premier annual collector car events. At that inaugural event, many collectors sloshed through a muddied field on Auburn's west side to bid on the modest number of vehicles. One Duesenberg sold for a then unheard of $61,000. Seemingly overnight, a new industry was born, positioning the Kruse family, namely Russell Kruse and Dean Kruse, directly in the center of the newfound craze. In the years since, Kruse has sold his company twice and established several museums in Auburn to help celebrate and promote the rich automotive heritage, both locally and nationally. (Courtesy of KPC Media.)

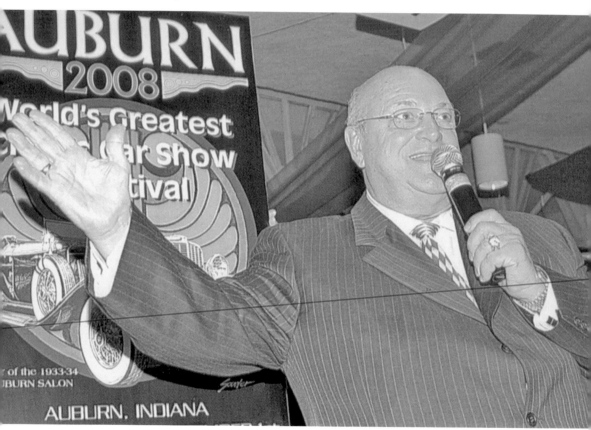

CHAPTER THREE

Artists and Artisans

When texting completely takes over our communication habits what will become of words? This is a question I'm not able to answer, but one thing is certain: people will miss hearing the wonderful poetic sounds of words and be poorer for it.

—Rachel S. Roberts

Rachel S. Roberts is a gifted artist by any measure, having been a writer in multiple media, including newspaper, books, and award-winning plays for many years. Through this quote, one may remember another that goes something like "to understand what the artist is trying to say, you first must know the question or questions being asked."

Art exists in many forms. It can be found in the designs of classic buildings by the likes of Alvin M. Strauss, a Kendallville native who designed the present-day Auburn Automobile Museum, one of the most distinctive structures in the community. It can be found in the John Souder posters that are produced annually to promote the ACD Festival and that appear in the windows or on the walls of virtually every business in town. It can be found in the works of masters of the written word like Roberts or poet Frank Carleton Nelson. Or it might be found in photography from the likes of Kelso Davis, who is responsible for more than a few of the images in this book.

In reality, Auburn has always had a vibrant undercurrent of artistic culture. It's been more or less prevalent at different times, but there has never been a lack of it. No matter the form, it exists in the heart of Auburn, "the Classic City." In fact, though many longtime residents have grown numb to it because it is a relatively common sight, the Auburns, Cords, Duesenbergs, and other classic automobiles that regularly cruise our streets are literal rolling works of art.

If you have not yet noticed, take a break from your frantic pace of life and look around. Then, ask yourself, "What in the Auburn community inspires and speaks to me?" Now that you understand the question, you will no doubt find the answers.

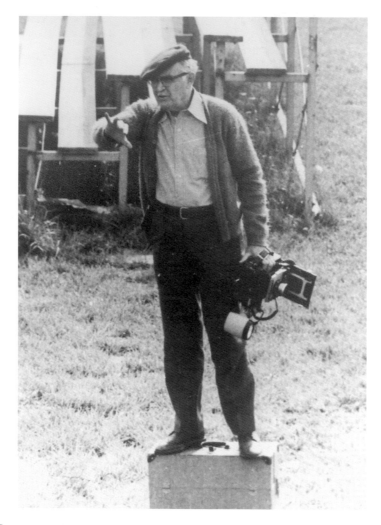

Kelso Davis

Kelso Davis, a local photographer, took many of the photographs appearing in this book. He was well known and admired throughout the Auburn community. Kelso and his wife, Margaret Davis, owned and operated the Davis Studio in Auburn for 60 years between 1938 and 1998. As a result of their longevity, many high school classes had the rare experience of having their reunion photographs taken by the same photographer who took their graduating class picture. From 1967 to when Auburn High School closed, Kelso took the photographs, including those of seniors and underclassmen as well as organizations and sports teams, placed in the yearbook each year. He was a 60-year member of the Auburn Rotary Club and served on the Auburn City Council in the 1940s. Before the growth of color photography, Margaret became a master at hand-tinting the studio's brown-toned matte prints with oils and kept the studio open in 1944–1945 while Kelso served in the US Army. Photography brought Kelso and Margaret Davis together. One day, while working at the Anderson photography studio, Kelso was retouching a negative when he mentioned that he would like to meet the girl in the photograph. His friend knew Margaret and set up a blind date. They were married in 1934. Kelso passed away in 2000, and Margaret passed in 2010. In 2012, their daughters, Diane Manon, Sherri Sible, and Loraine Hartranft, established an endowment fund through the DeKalb County Community Foundation to honor the memory of their parents. The Kelso and Margaret Davis Community Fund aims to support projects in the arts, beautification, and general community needs. (Courtesy of the William H. Willennar Genealogy Center.)

Alvin M. Strauss

Alvin Max Strauss was an Indiana architect and designer who designed many landmark buildings in Indiana and Ohio during the early 20th century. Though he is more commonly associated with Kendallville and Noble County, one of his works is passed daily by many citizens of Auburn and visited by thousands on an annual basis. Strauss deigned the 1930 Art Deco–style showroom and administrative buildings of the Auburn Cord Duesenberg Automobile facility, which is today's Auburn Cord Duesenberg Automobile Museum. Among his other well-known commissioned works are the Allen County War Memorial Coliseum, the Lincoln Bank Tower, and the Embassy Theatre and Indiana Hotel in Fort Wayne. The Court Theater, which was opened in 1916, was remodeled in 1928 into an Atmospheric-style theater by Strauss prior to its closing. (Both, author's collection.)

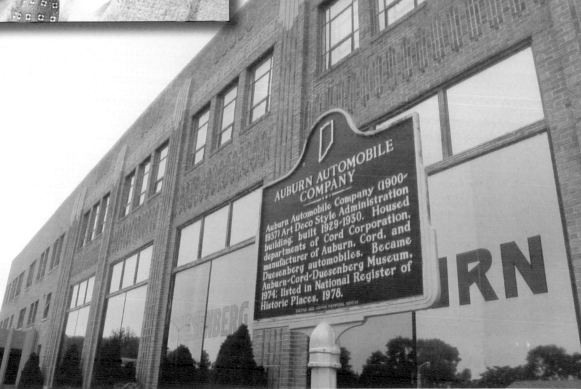

Frank Carleton Nelson

Previously a traveling salesman and a local teacher, Frank Carleton Nelson gained fame as an author and poet. His poetic interpretations were later broadcast through the medium of radio, earning him a national reputation as "Indiana's radio poet." He wrote his first poem on slate while a pupil in the Bear Creek District School near the old farm home in DeKalb County. A master of dialect poetry portraying common life as a Hoosier, he offered a warm and sympathetic voice that won many radio fans. He became one of the most popular radio artists, broadcasting on the *Chicago Tribune's* WGN, and also published books of poetry, most notably *The Evening Hour* and *Along Life's Road*. Nelson was educated locally and graduated from Auburn High School. (Author's collection.)

Will Cuppy

Will Cuppy played the pipe organ at the Auburn Presbyterian Church as his mother, a Pennsylvania Dutch schoolteacher, sang. A 1902 graduate of Auburn High School, he entered the University of Chicago, where he acted in theater and worked as a campus reporter for several Chicago newspapers before graduating in 1907. He continued studying there until 1914, taking a Master of Arts in English and setting out for New York, where he supported himself by writing advertising copy. He served briefly in World War I, and later began contributing book reviews to the *New York Tribune*. In 1926, Cuppy began writing a weekly column for the *Tribune's* successor, the *New York Herald Tribune*, which he continued until his death 23 years later, reviewing more than 4,000 titles of crime and detective fiction. Cuppy produced other magazine articles and books, always working from notes on three-by-five-inch index cards. His final years were of poor health and depression. Facing eviction from his apartment in 1949, he overdosed on sleeping pills, passing away 10 days later. His remains were cremated and buried next to his mother in Evergreen Cemetery. His book, *The Decline and Fall of Practically Everybody*, was published posthumously and spent four months on the *New York Times* bestseller list. His grave was unmarked until 1985, when local donors purchased a headstone with the inscription: "American Humorist." (Author's collection.)

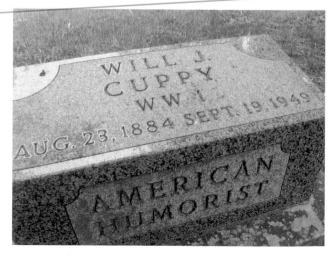

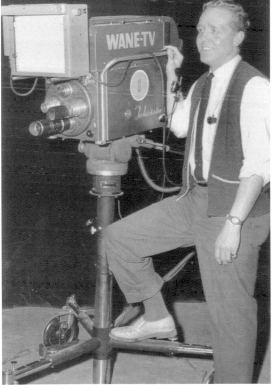

John Souder

John Souder has designed posters, as well as dash plaques, lapel pins, and other memorabilia, for the Auburn Cord Duesenberg Festival since 1981. Annually, the poster design for the year's theme is unveiled by Souder and the festival, and then, prints of the posters begin to make their way into the businesses and homes of those in the Auburn community while also gracing the cover of the festival guide and other printed/electronic materials. Interestingly, though his artwork is synonymous with the Auburn Cord Duesenberg Festival, Souder originally agreed to do a poster for one year only and had never had any interest in doing art involving automobiles. That was more than three decades ago, and first prints of his work now sell for hundreds, sometimes thousands, of dollars. It is a role he stumbled into through acquaintances. At that time, very few, if any, could have predicted what the festival would become, and also at that time, Souder was an art director for a producer of color swatches in Noble County and was also a freelance commercial artist. Earlier in his career, he served as the art director of WANE-TV, the Fort Wayne CBS affiliate. After serving in that role for a year, he moved on to a bigger station outside of Indiana and began freelancing for department store fashions before returning to Indiana. (Both, courtesy of John Souder.)

Rachel Sherwood Roberts

Rachel Sherwood Roberts was born in South America to missionary parents, learning Portuguese before English. When her parents retired, they returned to their home in South Carolina. After obtaining her master's degree, Roberts taught high school, then kindergarten, and then college as she and her husband moved around before settling in Indiana, where she continued teaching. As their family grew to include two daughters and a son, she began writing features for newspapers and, for 15 years, wrote "View and Review," a personal opinion column for the *Evening Star* in Auburn. She has written a number of cover stories for *Traces of Indiana & Midwestern History* and is the author of several books, including *Art Smith, Pioneer Aviator*, and her *Red Earth* series. An accomplished playwright, her play *Gentry's Auction* won top honors at the Indiana Theatre Conference. As of this publication, Roberts serves as editor of *Contact*, the Greater Fort Wayne Aviation Museum newsletter. During the 1970s and 1980s, she served on the Eckhart Public Library Board, and in her 1999 guidebook, *Auburn Is a Dancing Lady*, she calls the library "a jewel" while observing that Auburn's library represents a vision of civic responsibility. Roberts is a longtime member of the Auburn Arts Commission. (Courtesy of Rachel Sherwood Roberts.)

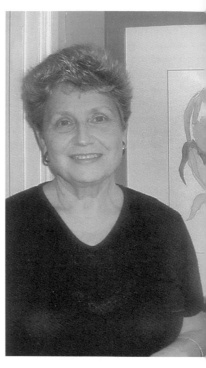

Barbara Olenyik Morrow

Born in St. Louis, Missouri, Barbara Olenyik Morrow grew up rooting for the St. Louis Cardinals, reading the sports pages about the players, their stats, and the team's chances of winning the pennant. She also was an avid book reader, especially of Nancy Drew mysteries, biographies, and historical fiction. Reading also inspired her to write stories and poems. In college, she studied journalism with plans for a newspaper career. While at Indiana University, she wrote and edited stories for the campus newspaper. Following the earning of a master's degree in journalism, Morrow worked as a reporter for newspapers in Bloomington, Louisville, and, later, Fort Wayne. She began writing opinion articles and was a 1986 finalist, along with two coworkers, for the Pulitzer Prize in editorial writing. Upon moving to Auburn in 1979, a librarian mentioned the rich Indiana literary heritage, and Barbara was prompted to learn more about Indiana authors, which would inspire *From Ben-Hur to Sister Carrie: Remembering the Lives and Works of Five Indiana Authors*. The mother of four sons, she left the newspaper business to focus on writing books. Since the publication of her first book, *Those Cars of Auburn*, she has written several others. Her 2011 book, *Nature's Storyteller: The Life of Gene Stratton-Porter*, introduced the pioneering Hoosier outdoorswoman to a new generation of young adults while also definitively answering the question about when Stratton-Porter moved into the Wildflower Woods home at Sylvan Lake near Rome City. (Courtesy of Barbara Morrow.)

Pat Delagrange

It is virtually impossible to live in Auburn, visit, or perhaps even drive through without seeing the work of Pat Delagrange, a self-taught artist who is well known and regarded throughout northeastern Indiana. Her murals and whimsical works of art are displayed in homes, schools, churches, restaurants, and businesses throughout the region. The roots of her artistry trace back to a few art courses and a very brief stint in an art correspondence school. In the 1970s, a former lumberyard in Grabill, Indiana, became an art studio for Pat, where she and her husband, Merv, also leased space to other small businesses. Fourteen years later, they sold the business and moved to Auburn. In the 1990s, they purchased the 6,000-square-foot former Auburn Baptist Church building in the downtown area. It was built in 1873, and the congregation disbanded in 1977. Following the church's vacation of the building, the DeKalb County Senior Citizens Council bought it. Pat began operating Heavenly Treasures from that location. A few transitions occurred in the years that followed until 2007, when Pat and Merv made the building their residence and transformed it into a charming display for folk art, home decor, and accessories. Though the building is no longer a functioning church, Pat has always desired that it will continue to honor God, inspire others, and share His love. (Author's collection.)

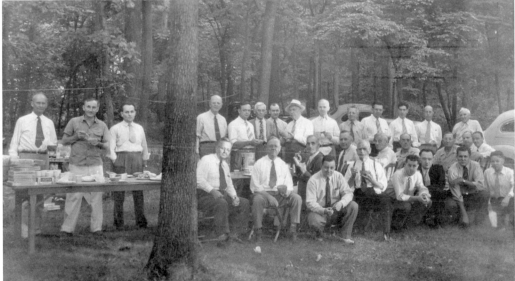

George Hachet

George Hachet was a printer by trade, working alongside many family members at the Auburn Printing Company. In fact, his sister was Ida Buchanan, the wife of Verne Buchanan, chief proprietor of the Auburn Printing Company. George Hachet was married to Mabel Madden and was a well-known Auburn artist. Following his passing, his oil paintings depicting picturesque landscapes were displayed in shows honoring him and his work and encouraging future generations of artists. Here, several area gentlemen gather in a wooded area for a club photograph. Hachet is seated at a table just right of center, wearing a dark blazer and glasses. Standing behind him to the right is H.L. McKenney, another local legend showcased in this book. (Courtesy of the William H. Willennar Genealogy Center.)

Mark Shaw

Mark Shaw is a lawyer turned author with several publications and high-profile collaborations to his credit. He was a criminal defense attorney in Indiana for many years and also practiced entertainment law before writing several books. His columns have appeared in *USA Today*, *National Pastime*, *Indianapolis Monthly*, and *Indiana Lawyer*, among others. A 1963 graduate of Auburn High School, his first job was in Auburn at Rohm Chevrolet, where he washed cars. Sometime later, he recounted the nature of the repairmen's work devotion and their prideful support of their own families as an early impression upon him. As an auburn youth, he played little league baseball for Andres Insurance, and one year found himself on a team that lost every game. Despite this disappointment, he would later find higher achievement in baseball through an opportunity to collaborate with New York Yankees great Don Larsen on a book chronicling his perfect game in the 1956 World Series. In 1978, Shaw co-founded the *Aspen Daily News* in Colorado. As a legal analyst, he predicted the eventual outcomes of the Mike Tyson and O.J. Simpson trials for CNN, ABC, and ESPN. While serving as a radio host in Bloomington, he initiated and was a driving force behind a campaign that sought Indiana University basketball coach Bob Knight's firing. Shaw's effort, though successful, cost him his marriage and relationship with his stepchildren. The "knightmare" later prompted a closer connection with God, and precipitated a new love, seminary, and an introduction to the biological child he never knew existed. He detailed those events in his book *Road to a Miracle*. (Courtesy of Mark Shaw.)

CHAPTER FOUR

Educators and Informers

An historical society ought to be organized in connection with the old settler organization and the narratives of the pioneers yet living would give present pleasure and prove of lasting importance to generations yet to be.
—William H. McIntosh

The quote that introduces this chapter comes from one of the most prominent educators the Auburn community has ever known, William H. McIntosh. It's appropriate that his words introduce this chapter, even though his narrative appears much earlier in this book.

In Auburn, many buildings stand as a public display and evidence that the community values strong educational foundations. However, the buildings, despite whatever history and intrinsic beauty they may hold, take a back seat to the work of the men and women who provide the instruction.

In many regards, every man or woman in this book can be considered a teacher. In fact, much like McIntosh, many educators appear both before and after this chapter. It's no indictment of their teaching abilities. Instead, it is a testament to their personal resilience and ability to live beyond a single calling. The legendary locals in this chapter, though balanced in their own rights, clearly dedicated the vast majority of their lives to their chosen purpose and have firmly solidified their connection to the larger community.

In this chapter, there are educators turned superintendents, such as B.B. Harrison and H.L. McKenney. There are stories of legendary teachers and coaches like Cecil "Zeke" Young, and there are profiles of the historians who endeavor to preserve the legacy of their mentors. There is a great connection and bond between instructors and students as they mature to upstanding citizens within the community, at which time they too become teachers to the generations that follow.

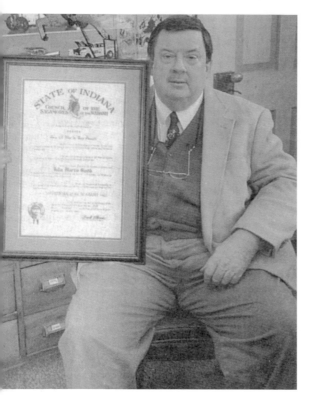

John Martin Smith

John Martin Smith's contributions to the preservation of Auburn and DeKalb County history could fill volumes of books. Any attempt to encapsulate the entirety of its scope within a few paragraphs undoubtedly would fall well short. He was born in 1939 at Dr. Bonnell Souder's hospital in Auburn and raised in nearby Butler. In 1965, he came to Auburn and joined the law practice of Edgar W. Atkinson, who had begun the practice in 1909. Later, his son Thompson Smith joined the practice. The elder Smith was a founding board member of the Auburn Cord Duesenberg Automobile Museum in the 1970s and, later, the National Automotive and Truck Museum of the United States (NATMUS). He authored and put together numerous books containing vintage photographs and historical facts about area counties. Due to his many contributions, Gov. Frank O'Bannon recognized Smith by naming him a Sagamore of

the Wabash; Smith is seen holding his framed Sagamore of the Wabash certificate at left. He is seen second from left posing with a copy of his *History of DeKalb County, Indiana*, book, published in 1992 for the county's sesquicentennial celebration. Smith is pictured second from right at an Eckhart Public Library–hosted event on local history. At right, wearing his favorite bib overalls, he is at the National Automotive and Truck Museum of the United States (NATMUS). Smith and his wife, Barbara "Bobbie" Smith, both died tragically in an automobile accident on Interstate 69 in 2011. Smith was the DeKalb County historian from 1982 until his tragic passing. Barbara was a teacher and also worked as a legal secretary and bookkeeper at John Martin's law office in addition to being very active in many community organizations. (From left to right, three images courtesy of the William H. Willennar Genealogy Center; far right image courtesy of KPC Media.)

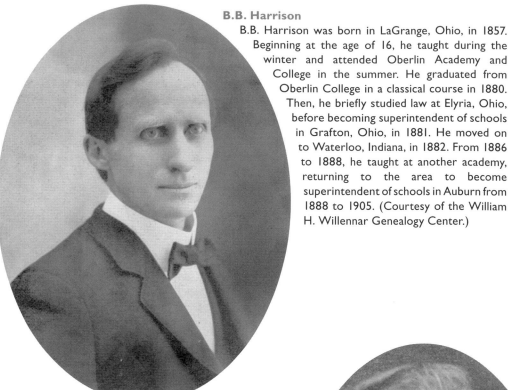

B.B. Harrison

B.B. Harrison was born in LaGrange, Ohio, in 1857. Beginning at the age of 16, he taught during the winter and attended Oberlin Academy and College in the summer. He graduated from Oberlin College in a classical course in 1880. Then, he briefly studied law at Elyria, Ohio, before becoming superintendent of schools in Grafton, Ohio, in 1881. He moved on to Waterloo, Indiana, in 1882. From 1886 to 1888, he taught at another academy, returning to the area to become superintendent of schools in Auburn from 1888 to 1905. (Courtesy of the William H. Willennar Genealogy Center.)

H.L. McKenney

H.L. McKenney was the Auburn High School principal in 1916. He was also a mathematics teacher and taught debate. He began serving as superintendent of Auburn schools in 1923 and served in that role until his retirement in 1958. He was known for his continual efforts to better the schools and their environments, and among his accomplishments were the implementation of a book rental system for the first five grades and the construction of a new junior high school building.

Ever since two schools were named in their honor, both Harrison and McKenney have been linked in the Auburn community for decades. The two schools were eventually combined for use as a single elementary school, aptly named McKenney-Harrison Elementary School. Interestingly, Harrison has a distinction of having two school buildings of different eras named in his honor. Prior to the Harrison Building being built, the first high school built in Auburn was renamed for Harrison. The 1909 Auburn High School yearbook notes: "Here, in the year 1876, the first High School was erected, better known now as the Harrison Building." In 1930, the old Harrison School building was razed and replaced by the new Harrison Grade School in 1931. (Courtesy of the William H. Willennar Genealogy Center.)

"Auburn's Coach" Cecil "Zeke" Young

A coach on the field and off, Cecil "Zeke" Young came to Auburn having graduated from DePauw University with a degree in economics and excelling in football, basketball, and track and, later, earning a master's degree from Indiana University. He coached football, basketball, and track at Auburn High School, where he was also a teacher of history and physical education. He coached the Auburn Red Devils from 1924 through 1955, retiring from teaching in 1960. His tenure included four undefeated seasons and 11 conference championships in the 1940s and 1950s. During one stretch in the 1940s, Young's teams won 25 consecutive games, helping him compile a career record of 142 wins, 63 losses, and 14 ties. Zeke coached basketball for 12 seasons, winning seven sectional titles. He was among the first nine men inducted into the Indiana Football Hall of Fame and became a charter member of the newly formed DePauw University Athletic Hall of Fame in 1987. The current DeKalb High School football field is named in his honor as well. (Both, courtesy of the William H. Willennar Genealogy Center.)

65

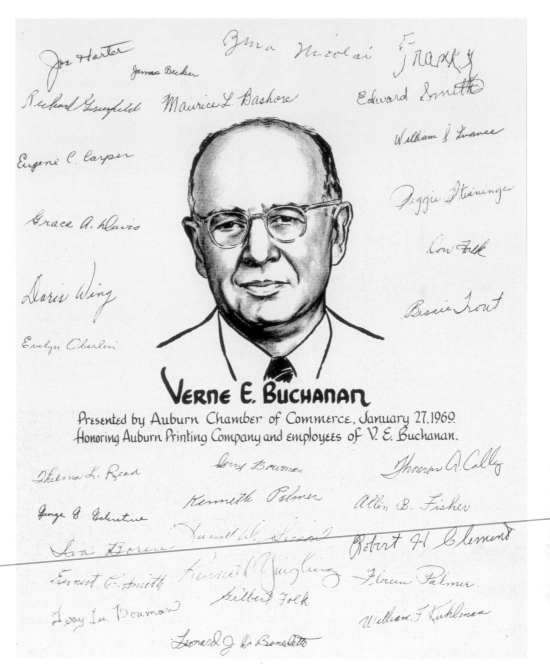

Verne E. Buchanan
This sketch of Verne E. Buchanan surrounded by signatures was on an Auburn Printing Company plaque that was presented at a chamber of commerce meeting in 1969 upon Buchanan's retirement. The signatures are from employees of the Auburn Printing Company, which Buchanan owned from 1916 until 1968. (Courtesy of the William H. Willennar Genealogy Center.)

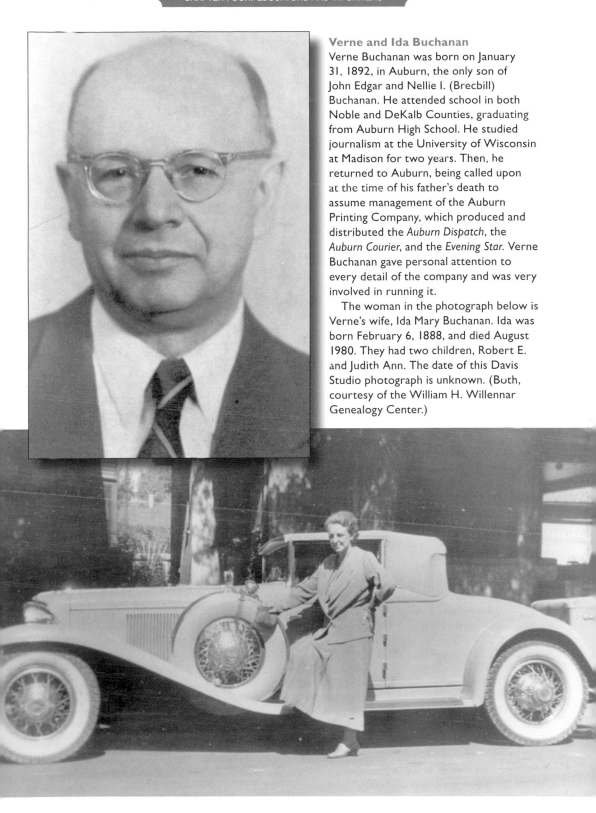

Verne and Ida Buchanan

Verne Buchanan was born on January 31, 1892, in Auburn, the only son of John Edgar and Nellie I. (Brecbill) Buchanan. He attended school in both Noble and DeKalb Counties, graduating from Auburn High School. He studied journalism at the University of Wisconsin at Madison for two years. Then, he returned to Auburn, being called upon at the time of his father's death to assume management of the Auburn Printing Company, which produced and distributed the *Auburn Dispatch*, the *Auburn Courier*, and the *Evening Star*. Verne Buchanan gave personal attention to every detail of the company and was very involved in running it.

The woman in the photograph below is Verne's wife, Ida Mary Buchanan. Ida was born February 6, 1888, and died August 1980. They had two children, Robert E. and Judith Ann. The date of this Davis Studio photograph is unknown. (Both, courtesy of the William H. Willennar Genealogy Center.)

Del Mar Johnson

This photograph shows a group of 17 men and one woman at the Indiana Bell Telephone ground breaking. The man third from left is Del Mar Johnson. A 1943 local high school graduate, Johnson entered the US Navy and served in the southwest Pacific until 1946. He returned to Auburn and served on the local draft board in 1948 and 1949. Ever active in the community, Johnson served as president of the Auburn Jaycees, the chamber of commerce, and Greenhurst Country Club and was a commander of the American Legion Post No. 97 and a member of the Auburn City Council, the city planning commission, and the board of zoning appeals. However, he is best remembered for conceiving the idea of creating a "reunion of the ACD cars" and contributions stemming from it, as chairman of the Auburn Cord Duesenberg Reunion, president and founder of the ACD Festival, and director of the Auburn Cord Duesenberg Museum. Verne E. Buchanan is to Johnson's left. The man with the shovel on the right is Mayor Jerry Oren (Courtesy of the William H. Willennar Genealogy Center.)

John Bry

In 1984, a 13-year-old John Bry was working on a 4-H project on citizenship when he interviewed John Martin Smith about the topic. During that discussion, Bry shared a photograph of the renowned Madden Building that his great-great-uncle Alpheus Madden had constructed to house his monument company. Smith immediately recognized the distinctive arches and explained to the young Bry that they were at the city barn. Bry went to the barn and found the disassembled arches run over with weeds and general neglect. That moment ignited a long quest to secure a new home and restoration of the one-time local landmark. Along the way, the arches came under Bry's ownership since he was an heir of Madden's, and the city had chosen to no longer store them. Approximately 10 years after learning of their location, Bry was one of 11 selected for an internship with Gov. Evan Bayh and Lt. Gov. Frank O'Bannon. He was assigned to work on the Indiana Main Street Program and with the Indiana Department of Commerce. It was at this time he was preparing to gift the arches to the city of Urbana, Ohio, which had expressed interest in reconstructing them in the community. As he was drafting the letter to do so, he was contacted about an opportunity to place the arches at a newly established senior citizen's center, and much of the funding to do so was already committed. He agreed, and the arches were placed at the William Heimach Senior Citizen's Center in Auburn. That year, local writer Rachel Roberts wrote a column recognizing Bry as one of 10 people in the community who made a difference during 1997. Bry later went to work in the Buffalo area of New York, where he had the opportunity to work on and be a significant contributor to many restoration and historic preservation projects. He returned to DeKalb County and became the executive director of the tourism bureau in Noble County. A few years later, his role evolved to focus exclusively on community asset development, pioneering several successful programs, including the Tombstone Trail, Indiana's Farm to Fork, and others. He purchased and restored the home of Dr. John Baxter on Sixth and Cedar Streets and was elected historian of DeKalb County following the passing of his predecessor, John Martin Smith. (Courtesy of John Bry.)

Dave Kurtz
He came to DeKalb County from neighboring Noble County in 1975 for what he expected would be a brief residency. Dave Kurtz instead became a legendary local, covering the stories of the community and the lives within it as a reporter, photographer, and editor of the *Evening Star* newspaper. He and Lizbeth A. "Betsy" Rodecap-Kurtz were married and made their home in the same neighborhood where Betsy was raised. Born in Kendallville, where he was valedictorian of the East Noble High School class of 1969, Kurtz then graduated from Michigan State University with high honors in 1973. Following a brief stint as a radio news announcer in Lansing, Michigan, he took on the role of managing editor of the *Evening Star* newspaper in 1975 and has been a mainstay of reporting and overseeing the publication to this date. During his tenure, he has covered such local events as the US Supreme Court case of *Stump v. Sparkman*, based on a DeKalb County judge's sterilization order for an Auburn teenager, and the rise of Auburn's collector car auction industry. He also photographed DeKalb High School's state championship games in baseball and football. (Courtesy of KPC Media.)

CHAPTER FIVE

Community Leaders and Servants

It seems to be that he is a wise and happy man who can live proportionately in the past, present and future and not spend too much of his time in either one. This is the golden, glorious age, and the world is getting better every day.

—Frank M. Powers

Auburn has been blessed with several individuals who have stepped up to guide it along the path for which it is destined. The quote that starts this chapter is from one such servant. The Hon. Frank M. Powers was the presiding judge of the DeKalb-Steuben Circuit Court when the cornerstone for the current DeKalb County Courthouse was ceremonially installed on July 26, 1911. In addition to Gov. Thomas Marshall and a handful of other individuals, Powers was asked to be a speaker at the event.

Powers, quite the optimist that he was, well represents the legendary locals presented in this chapter. They are recognized as mayors who each oversaw the achievements of their administrations, business leaders who guided the flow of commerce within the community, and judges or law enforcement professionals who instilled proper justice and order.

The laying of the cornerstone brought out the entire county and many visitors from outside its boundaries. They were treated to a magnificent celebration of achievement that took the cooperative efforts of many. That spirit was likely well engrained in the mind of Powers, who at that ceremony later commented: "There is another cornerstone that was laid long years ago by the sturdy pioneers of whom I have spoken. That cornerstone of this structure is intelligent, industrious and patriotic citizenship of our county. You are building up the honorable records of men living and dead: upon the good name of your county, at home and abroad. This is the foundation, that solid rock upon which this structure must stand."

Mayor Donald Garwood

Don A. Garwood was born March 9, 1858, in Cassopolis, Michigan. He graduated from the University of Michigan in 1881 and moved to Waterloo to enter the law office of Best and McClellan, where he read and studied law. In 1883, he was admitted to the bar and became partner with McClellan following the retirement of attorney Best. He was active in many civic and fraternal organizations. He was on the initial board of directors of the Auburn Improvement Association, which was formed in 1895, and the Auburn Commercial Club, which was organized in 1903. Garwood was also a member of the Waterloo Coty Lodge No. 307, Free and Accepted Masons, and was a worshipful master of DeKalb Lode No. 214, Free and Accepted Masons. He and his wife, Jennie McClellan Garwood, resided at 207 South Van Buren Street in Auburn. He was president of the Auburn Town Board prior to his May 1, 1900, election as Auburn's first mayor. The contest saw him defeat Thomas A. Sprott by a two-vote margin of 364 to 362. (Courtesy of the William H. Willennar Genealogy Center.)

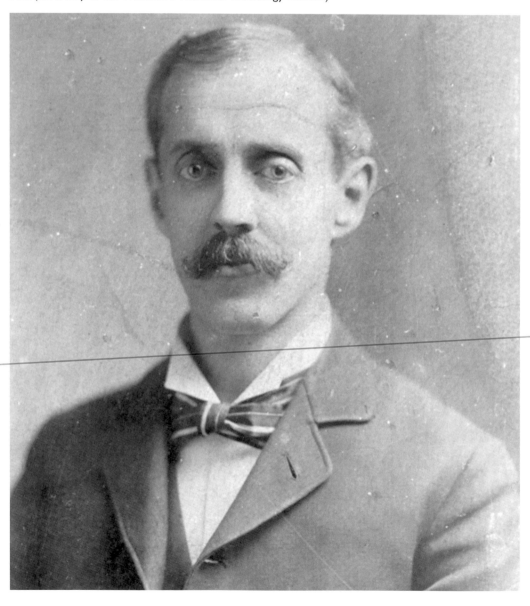

Mayor Thomas H. Sprott

Thomas H. Sprott earned prosperity and respect from those who witnessed his hard work, perseverance, and ambition. He was born in Auburn on September 4, 1850, and grew up in Auburn while taking part in a shoe business as a partnership with his father until 1875, when he went into real estate and insurance. He continued that line of work for many years and was known to have a keen ability for business. On September 1, 1902, Thomas H. Sprott became mayor after having been narrowly defeated by Garwood in the 1900 election. Sprott was active in the Masonic lodge and served on the school board and the DeKalb County Council. He was a founding director of the Auburn Commercial Club. He married Abagail J. Potter, who was said to have moved in the best social circles and had been a prominent member of the Ladies' Literary Society. (Courtesy of the William H. Willennar Genealogy Center.)

Mayor James W.Y. McClellan

James W.Y. McClellan was a well-known member of the Auburn community who achieved success as a self-made man. He was born November 12, 1855. Following high school, he entered the literary department of the University of Michigan at Ann Arbor in 1879. After his first two years of study, his health declined, and he returned home to tend to the family farm for the next 20 years. During that time, his health improved, and the farm became financially successful. He later became occupied as a real estate broker and dealer in fertilizer. Success continued to follow as his reputation as a man of good business ability and sound judgment continued upward. Politically, McClellan was a strong advocate of the Democratic party and active in councils, having been a member of the county council and several times appointed drainage commissioner. In 1903, he was elected mayor. He was elected again as mayor in 1914, and as of this publication, he is the only person to serve as Auburn mayor for two non-consecutive terms. While he was mayor, a gas plant was built and an interurban line was constructed through Auburn. His 1903 campaign slogan, "Health is Wealth," advocated an anti-spitting ordinance, which was copied and adopted by other area cities. He died April 13, 1940, at the age of 84. (Courtesy of the William H. Willennar Genealogy Center.)

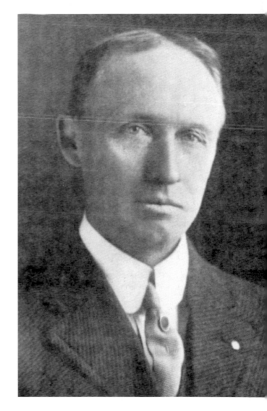

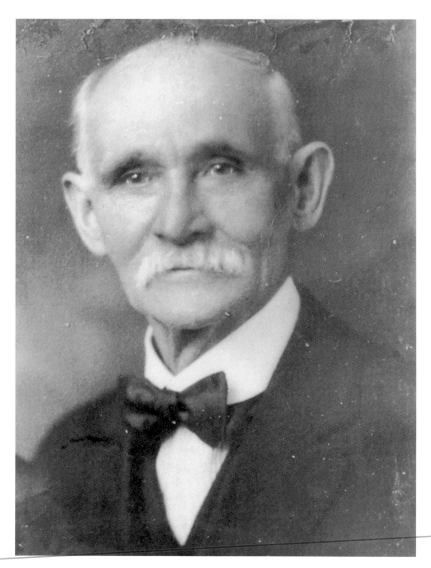

Mayor George O. Dennison

In 1866, George O. Dennison's father came to Waterloo with the intention of improving some recently purchased land and flipping it for sale. However, Dennison's parents found their Indiana home more to their liking than the Ohio homestead and relocated the family. Dennison had always given his attention to agricultural pursuits, but in 1880, he engaged in the ice business, having constructed an artificial lake on his farm, and soon boasted of a flourishing business that provided ice to the towns of Waterloo, Auburn, and Garrett. Dennison held many elected positions until his election as mayor of Auburn, serving from 1906 to 1910. Following that term, he resumed his previous position as deputy clerk. A fire in March 1913 destroyed many of the community's record books. Dennison, having been in his position for many years and having intimate knowledge of much of those records, was appointed and commissioned to restore the destroyed records. In 1873, Dennison married Joanna Bowman. Later in life, Dennison was sometimes called upon to offer recollections of DeKalb County prior to many public improvements. He talked of the rough and unsightly appearance of the country, which was characterized by a complete absence of quality roads and bridges. Mayor Dennison died on March 1, 1925, while still employed at the clerk's office. (Courtesy of the William H. Willennar Genealogy Center.)

Mayor Eli Walker

Eli C. Walker was a prominent businessman for many years and, in addition to being highly popular in the community, was elected mayor of Auburn, garnering the largest number of votes ever cast for any candidate up to that point. In 1880, when Walker was 12 years of age, the family sold their Ohio property and moved to DeKalb County. He was educated locally and attended Tri-State Normal in Angola. He later taught in local schools for 15 years. Upon his marriage to Edith Chaney in 1889, he gave up teaching and took on employment as an assistant bank cashier in Corunna and then tried his hand at shipping for La Due & Carmer Company in both Auburn and Fort Wayne. After returning to Auburn in 1915, he joined some other associates to incorporate the J.M. Cramer Company. Walker soon took on a controlling interest and continued to manage it until he sold in 1919. Being active in politics, he was elected mayor in November 1917, beginning his term January 7, 1918. Active in the Methodist Episcopal church, he was also a Scottish Rite Mason and a member of Mizpah Temple of the Mystic Shrine of Fort Wayne. He was also an Odd Fellow, and he and his wife were members of the Eastern Star at Auburn. In later years, he moved to Arizona. He apparently died there, but the date of his death is unknown. (Courtesy of the City of Auburn.)

Mayor Warren Lige
Warren Lige was mayor of Auburn from 1922 to 1935. He was born near Dutch Ridge in Allen County in 1883, moving to Auburn later in life and establishing Lige Heating and Ventilating Company. The company specialized in large commercial projects such as schools, public buildings, and factories. Mayor Lige served as president of the City National Bank from 1931 to 1936 and also as a member of the board of directors of several local industries. He was active in the Masonic lodge and the Auburn Chamber of Commerce. He died in 1948 at the age of 64. (Courtesy of the City of Auburn)

Mayor Lodie E. Potter

Mayor Lodie E. Potter had a career that was dedicated to service of the Auburn community. He served on the town council and city council as mayor and/or clerk-treasurer for a combined 62 years from 1898 to 1960 and also operated Potters' Grocery Store on South Main Street for over 50 years. Born in Allen County in 1885, he also attended Valparaiso University. He was married to Gladys Mochamer in 1909, and they lived on East Nineteenth Street. Potter became mayor in 1935 by defeating then three-term incumbent mayor Warren Lige by a vote of 1,672 to 1,086. Potter was elected to two additional terms (1940–1944 and 1944–1948) and was active in the Republican party and the Masonic lodge. (Courtesy of the William H. Willennar Genealogy Center.)

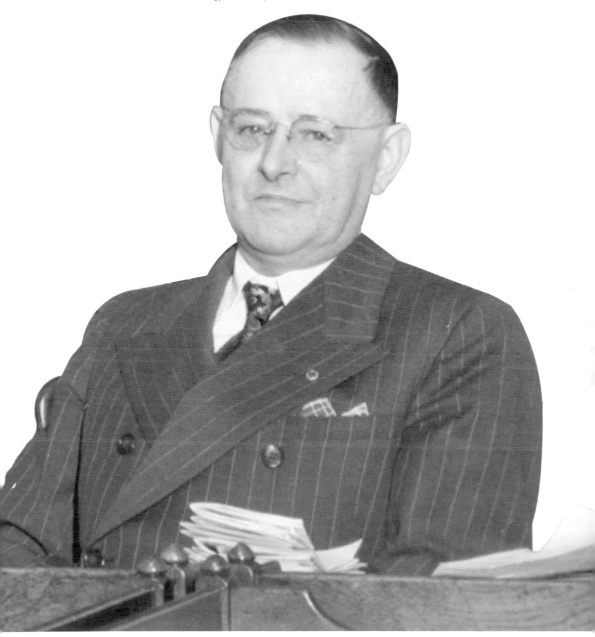

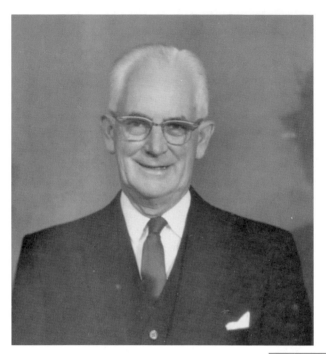

Mayor Hal G. Hoham

Hal G. Hoham was a native of Plymouth, Indiana, where he led a popular orchestra called Hal Hoham and His Bell Hops. He owned Auburn Grain Company and Hoham Company, a wholesaler of animal seed and feed. He was also active in the Auburn Lions Club and the DeKalb County Free Fall Fair Association and enjoyed Tennessee Walking horses. In 1947, he was elected to a term as mayor, in which office he served from 1948 to 1952, succeeding Lodi E. Potter. He was married to Mildred Humphrey in 1930, and following her passing in 1984, he had business interests in Columbia, South America, where he died in 1992. (Courtesy of the William H. Willennar Genealogy Center.)

Mayor Gerald "Jerry" Oren

Jerry Oren was elected as the 10th mayor of Auburn, serving three terms from 1952 until 1964. He was a Democrat and very popular among his fellow Auburnites. Born in Upland, Indiana, in 1910, he graduated from Indiana University and had scholarships in both football and swimming. Following college, he taught at a small college in Chicago and, later, moved to Auburn where he operated the Franklin Security Loan Company. His employment with Delta Electric Company had him relocate to Marion and Indianapolis before returning to Auburn in 1940. Upon his return, he formed Oren VanAmen with business partner Ben VanAmen. The company was a wholesale tool supplier located on Ninth Street just behind the Auburn Hotel. As the business grew, he relocated it to Fort Wayne. During his final term as mayor, the city and county built the Auburn-DeKalb Airport, which was dedicated on November 6, 1962. He married Barbara Sanders in 1934, and they lived on East Fifth Street where Barb developed and taught skits and dances for a variety show called the Canteen Blackout. The show was staged annually as a fundraiser at the Main Street YMCA. Mayor Oren died in 1975. (Courtesy of the William H. Willennar Genealogy Center.)

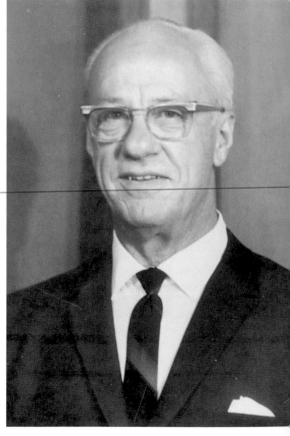

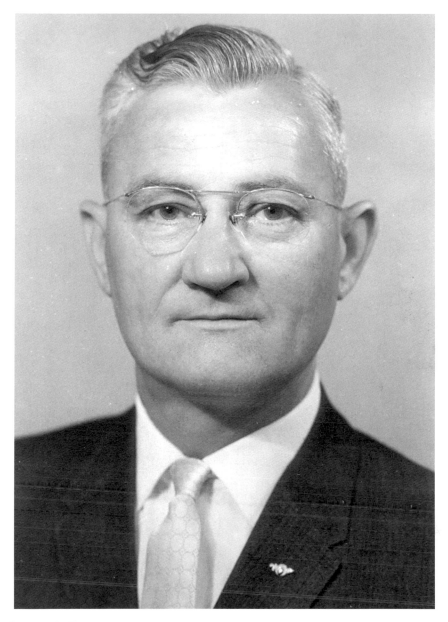

Mayor Clarren L. Boger
Clarren L. Boger was born in 1907 in Auburn Junction. He was elected to serve as mayor from 1964 to 1968. In 1922, he began working for the Auburn Rubber Company, retiring as vice president and production manager in 1959. In between, he and two fellow Auburn Rubber Company executives formed Sellers, Yoquelet and Boger Inc. in 1940 to manufacture aluminum molds for rubber toys. They sold the company in 1947 to Walter H. Ball, who changed the name to W.H. Ball Aluminum Castings Inc., and later, Ball Brass and Aluminum Foundry Inc. Boger married Fannie Garner in 1931. Together, they lived on Ensley Avenue and, later, on east Seventh Street where they maintained show gardens filled with roses and other flowers. He was an active Mason and a member of the Fort Wayne Scottish Rite and Mizpah Shrine. Mayor Boger passed away on August 11, 1999. (Courtesy of the William H. Willennar Genealogy Center.)

Mayor Don Allison

Don Allison served as mayor of Auburn from 1968 to 1972. He was born in Muncie in 1914 and graduated from Muncie Central High School and DePauw University. He and his bride, Frances McCormick, moved to Auburn in 1938 when his employment with Warner Automotive Parts Division of Borg Warner Corporation moved from Muncie to the former Auburn Automobile Company buildings. He and his brother Kenneth later formed Allison Corporation, a distributor of automotive parts and hardware. Allison was a founding board member and director of the DeKalb Memorial Hospital, a member of the YMCA board of directors, and served on the board of the Auburn State Bank for 40 years. Mayor Allison died in November 2000. (Courtesy of the William H. Willennar Genealogy Center.)

Mayor John Foley

John Leo Foley (November 22, 1925 to March 16, 2011) came to Auburn in 1930, graduating from Auburn High School in 1943. He then attended St. Joseph's College and served in the Air Force. He began employment with Foley Pattern Company in 1941 and served as president and chairman of the board until his retirement in 1991. He was an active contributor to countless civic and community organizations, including the Auburn Jaycees, DeKalb County YMCA and YMCA Foundation, the DeKalb County Free Fall Fair, the Auburn Cord Duesenberg Festival, and more. In 1968, he assisted in raising money to build the Auburn Community Pool and served as pool manager until 1972. He had also served as Auburn's park commissioner and police and fire commissioner. He was a member of the Auburn Board of Works and the DeKalb County Aviation Board and was a city councilman in addition to a stint as mayor from 1972 to 1976. Foley was a charter member of the ACD Museum and director of Family Shelter Inc., a four-county battered women's shelter. In 1996, John was honored with the Allen Graber Citizenship Award and was presented with the prestigious Sagamore of the Wabash in 2000. (Courtesy of the William H. Willennar Genealogy Center.)

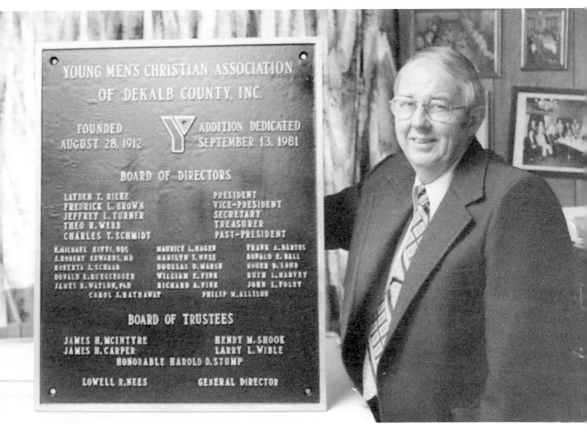

Mayor Jesse A. "Jack" Sanders

Jesse "Jack" Sanders was born in 1917 in Nashville, Tennessee. His family moved to Garrett in 1920 and relocated in 1924 to Auburn, where his father, Dr. J.A. Sanders, practiced and operated Sanders Hospital. Jesse graduated from Auburn High School, where he played basketball, and then attended Indiana University. In 1941, Jesse was drafted and ordered to the US Naval Academy. There, he was commissioned and sent to serve aboard the USS *Maryland*, a battleship that was assigned to the southwest Pacific theater of Word War II. He was decorated on seven occasions and retired at the rank of commander. He returned to Auburn after the war and worked for Wiley Export Company. In 1949, he purchased the Auburn Bowling Alley and, later, built the Auburn Bowling Center on Sprott Street to relocate the alley from its Seventh Street location. He also purchased the Kendallville Bowling Center and built the Butler Bowling Center. In 1953, he married Helen Blevins and became the brother-in-law of one-time Auburn mayor Jerry Oren. He served on the board of directors of Peoples Savings Bank for 40 years and was an active golfer, serving as the professional at Greenhurst Country Club for a time. He served as mayor from 1976 to 1984, which was a time of strong growth in the community. While mayor, the city extended Fifteenth and North Streets and created Grandstaff Drive, attracted new industry, beautified the downtown area, and improved Seventh Street. Sanders was a charter member of the Auburn Jaycees and the charter president of the DeKalb County United Fund and Cedar Creek Shrine Club. He also served as the president and was a long-term member of the Auburn Lions Club. Mayor Sanders died in 2002. (Top, courtesy of the City of Auburn; bottom, courtesy of the William H. Willennar Genealogy Center.)

Mayor Burt Dickman

Burt Dickman was a two-term mayor of Auburn from 1984 to 1991. While he was mayor, the city completed a waste treatment plant expansion, installed new windows in city hall, added antique streetlights around the courthouse square, and established a historic district in downtown square. Dickman graduated from St. Joe High School and attended Tri-State College in Angola. He served as a radio operator on the USS *Grampus* submarine while in the Navy during the Korean War. He and his wife, Elsie, got married in June 1951. Together, they own Auburn Mobile Home Sales & West Edge Park. He is a longtime member of the Auburn Kiwanis Club. Burt is one of three individuals responsible for the initial incorporating of what would eventually become the Auburn Cord Duesenberg Automobile Museum; Kurt Hahn and Fred Brown are the other two. He then became a founding member of the museum's board of directors as president of the board. (Courtesy of the William H. Willennar Genealogy Center.)

Mayor Norman Niles Rohm

Mayor Norman N. Rohm was born on December 6, 1929. He graduated from Auburn High School in 1947 and DePauw University in 1951. He served as mayor of Auburn from 1992 through 2000. During that time, eight residential subdivisions were added, a new electric department building was developed, and Fifteenth Street was extended to Touring Drive. Before serving as mayor, he was a school board member who acted in the role of chairman during a joint meeting of school offices that approved a resolution calling for consolidation of the Northwest and South Central School Districts to form the DeKalb Central School District, which became effective July 1, 1964. After the reorganization plan was approved, he was one of the board members elected in the 1964 primary to serve on the newly created district. He would serve DeKalb Central for 16 years. Rohm was also a US Marine, having served in Korea, and owned the Rohm Chevrolet dealership from 1965 to 1980. (Right, courtesy of the City of Auburn; below, courtesy of the William H. Willennar Genealogy Center.)

Mayor Norman Yoder

Norman Yoder graduated from Auburn High School in 1967. In 1972, he graduated from Purdue University with a degree in civil engineering and, later, owned and operated Yoder & Yoder Concrete for 27 years. He also built and owned the Auburn Skatin' Station with his wife, Peg (Smith), whom he married in 1972. Yoder briefly transitioned to a restaurateur before being elected mayor of Auburn in 2000. During his tenure, he has seen the completion of several community initiatives, including Rieke Park on the site of land donated by Glen T. Rieke, which once served as Auburn's airport. Another significant contribution of his administration is the establishment of Auburn Essential Services, a fiber-optic service that began as a means for bringing high-speed Internet to the business community and was later rolled out residentially to offer telephone, Internet, and television services. (Left, courtesy of the City of Auburn; below, author's collection.)

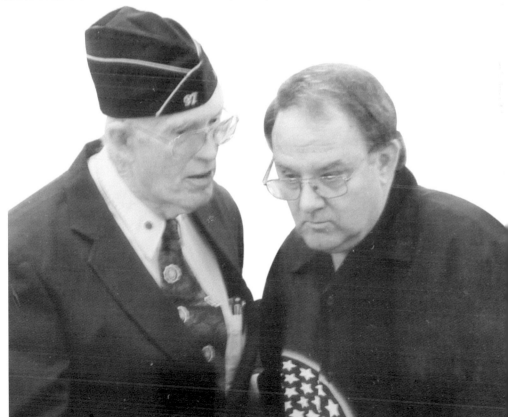

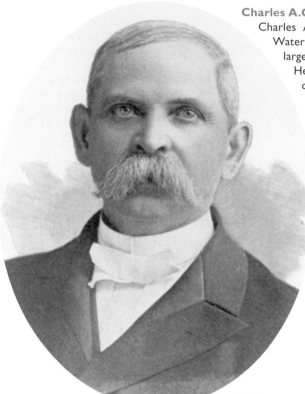

Charles A.O. McClellan

Charles A.O. McClellan came to Auburn from Waterloo in 1883 as a prominent lawyer with a large practice spread across several counties. He was president of the First National Bank of Auburn and served as circuit judge in 1879 and 1880. In 1888, he was elected to represent Indiana's 12th District as a Democrat in the US House of Representatives, serving two terms from 1889 to 1893. He died February 2, 1898, the result of heart failure, from which he had suffered approximately eight months. Upon his passing, he left a wife; one son, Charles; and two daughters, Jennie (Garwood) and Della (Silver). He was a 32nd degree Mason and was buried under the auspices of that order in Waterloo. (Courtesy of the William H. Willennar Genealogy Center.)

Judge Emmet Bratton

Emmet Bratton was DeKalb Circuit Court judge from November 17, 1904, until November 18, 1910. Upon completion of his term, Bratton was lauded by many of the attorneys who were present in the courtroom, citing an "appreciation of the honest, painstaking administration of Judge Bratton." Judge Frank M. Powers succeeded him. (Courtesy of the William H. Willennar Genealogy Center.)

Judge William P. Endicott

William P. Endicott's career was a testament to personal success while participating in the shaping of his community. Endicott was born March 28, 1881, near Galveston in Cass County, Indiana. He graduated from Galveston High School and then entered the law department of Indiana State University at Bloomington. On August 2, 1909, he married Nellie Davisson. In January 1910, he was admitted to the bar of Cass County and, the following April, DeKalb County. As a lawyer, Endicott displayed a mastery of legal principles and facts. Politically, Endicott aligned with the Progressive party founded by former president Theodore Roosevelt. Endicott was a member of the Free and Accepted Masons, attaining to the royal arch degree, as well as a member of the Knights of Pythias. (Courtesy of the William H. Willennar Genealogy Center.)

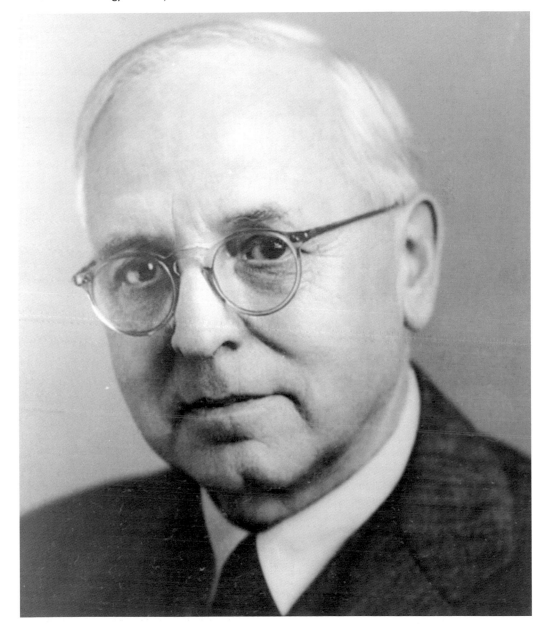

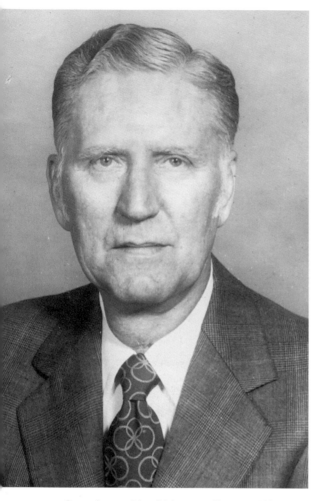

Walter and Harold Stump

Patriot, lawyer, and judge can pretty well describe the manner in which Walter Stump lived his life. A native of Noble County, he attended Tri-State College and graduated from Valparaiso University Law School. In 1911, he was married and settled in Auburn, Indiana, with the intent of setting up a law practice. P.V. Hoffman, whom Stump had contacted for advice regarding where to establish his practice, invited Stump to form a partnership, which he accepted. As World War I began, Stump was instrumental in forming and was selected captain of Company K for DeKalb County. From 1917 through most of 1919, Stump served in the 137th Field Artillery Regiment in training and action in France before his honorable discharge as a captain. He returned to Auburn and resumed his practice. In 1942, three months following the Japanese attack on Pearl Harbor, the 55-year-old Stump resumed duty in the armed forces, serving in the African and Italian campaigns before being honorably discharged as lieutenant colonel in 1946. He again returned to Auburn and again resumed his practice. That year, he campaigned for and won election to the office of DeKalb Circuit Court judge, where he served two six-year terms and declined to run for a third. He resumed being a lawyer until his passing in 1962. His wife, Clementine, was a charter member of the Auburn American Legion Auxiliary Post No. 97 and was a member of the Rebekah lodge and the Order of the Eastern Star.

Stump's son, Harold (pictured) was a 1935 graduate of Auburn High School with degrees from the Indiana University School of Law at Bloomington. He then became a special agent of the Federal Bureau of Investigation, with assignment to field offices in Washington, DC; Des Moines, Iowa; and New York City. In 1944, he resigned and joined the US Marine Corps. Following a brief stint as a drill instructor, he requested and received assignment to the 12th Marine Regiment of the 3rd Marine Division. He served in the Pacific theater of operations in World War II through the conquest of Iwo Jima and was assigned to the 3rd Amphibious Corps. He returned to Auburn following his honorable discharge in 1946. At the time, he and his father (Walter) had planned to become partners in law, but his father had become a candidate for circuit court judge, so Harold established his own practice. He practiced law until 1958, when he was elected circuit court judge, succeeding his father. He served five consecutive terms as DeKalb County Circuit Court judge, which lasted through 1988. Stump was also quite active in civic and youth welfare, including being one of the main organizers of Region II Foster Care Services Inc. The 1978 case *Stump v. Sparkman* (435 US 349) made national headlines and is considered the leading US Supreme Court decision on judicial immunity. Linda (Spitler) Sparkman sought to sue Stump because she had been sterilized years before at the request of her mother, in accordance with the judge's order. The Supreme Court held that the judge was immune from being sued for issuing the order because it was issued as a judicial function. (Courtesy of the William H. Willennar Genealogy Center.)

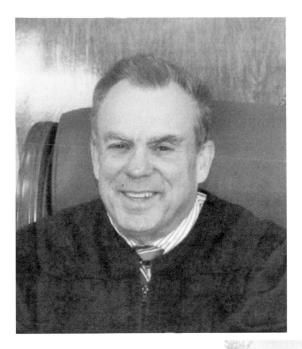

Judge Kirk Carpenter
In 1976, Kirk D. Carpenter joined a law practice run by Oak Husselman and his son, William H. Husselman. He remained with that firm until 2003 when he left to assume the bench of the DeKalb Circuit Court. Carpenter earned his undergraduate degree from Anderson College and his J.D. from Valparaiso University. In 2004, he was reelected with 100 percent of the vote while running unopposed. (Courtesy of the William H. Willennar Genealogy Center.)

Judge Dan Link
After graduation from Auburn High School, Dan Link moved to Chicago and became a police reporter, working for the *City Press Bureau*, the *Inter Ocean Press*, and the *Chicago Tribune*. During his time there, he also attended Northwestern University, obtaining his law degree in 1893. He began practicing law, returning to Auburn and becoming the first city attorney in 1897, overseeing its incorporation in 1900. In 1911, Link was elevated to a 32nd degree Mason. Seven years later, his outstanding lodge and public service were honored during a ceremony in Boston. During World War I, he was the first chairman of the DeKalb County chapter of the Red Cross. Pictured here is the home of Judge Link and his wife, Blanche, at 810 North Main Street. They built and owned the home from 1908 to 1925 and again from 1933 to 1952. This view, taken from Main Street, shows the south and west sides. (Courtesy of the William H. Willennar Genealogy Center.)

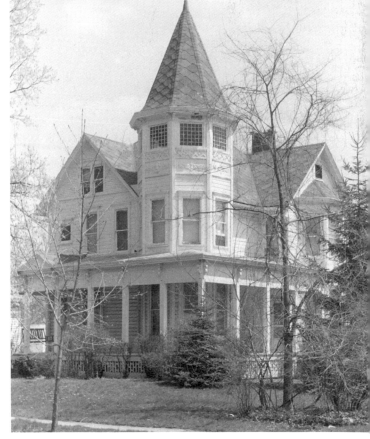

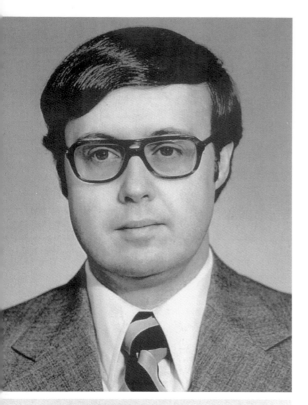

Judge Charles Quinn
After receiving his juris doctorate from Indiana University in 1967, Charles Quinn went to work for the Allen County Superior Court as a law clerk and, two years later, became partner with the law firm Smith & Quinn, where he remained until 1975. He was appointed Garrett City judge in 1974 and then DeKalb County judge in 1976. In 1977, the position was converted to DeKalb Superior Court judge, and Quinn was appointed by Indiana governor Otis Bowen to be the first Superior Court judge in DeKalb County. He won each reelection bid up until his passing at the age of 47 due to a tropical disease he contracted while vacationing in northern Africa. (Courtesy of the William H. Willennar Genealogy Center.)

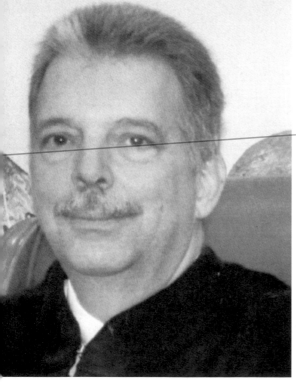

Judge Kevin P. Wallace
Kevin P. Wallace received a bachelor's of arts from Notre Dame and a juris doctorate from the University of Toledo before being admitted to the bar in 1979. Soon after, he set up a law practice in Auburn, which he ran until he assumed the DeKalb County Superior Court duties following the passing of then incumbent judge Charles Quinn. He was reelected several times following that appointment. (Courtesy of the William H. Willennar Genealogy Center.)

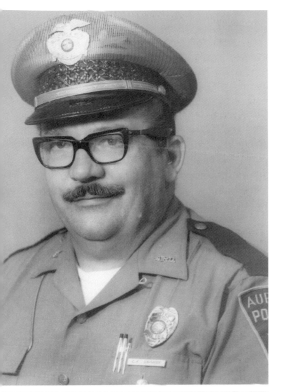

Cecil "Pete" Franklin Barhydt
Cecil "Pete" Franklin Barhydt was Auburn's police chief for eight years and a chief deputy sheriff for DeKalb County for five years, though he worked much of his life as a butcher and also at the Rieke Corporation. He was a member of the First United Methodist Church, where he was a former lay minister and Boy Scout scoutmaster, successfully guiding eight boys to Eagle Scout status. Barhydt was an Auburn little league coach and chapter dad for DeMolay International. In addition, he portrayed Santa Claus in the community during much of the 1970s. He passed away in 1999. (Courtesy of the William H. Willennar Genealogy Center.)

David Bunn
At the time of this writing, David Bunn had been with the City of Auburn Fire Department for 30 years and was the incumbent fire marshal. He received his associate degree from Ivy Tech, where he also is an adjunct professor. He also served as a board president for the United Way of DeKalb County and served on the DeKalb County Fair Association Board. (Courtesy of the William H. Willennar Genealogy Center.)

91

John W. Baxter

John W. Baxter was a well-spoken and analytical-minded citizen of Auburn, deeply passionate for the practice of law and said to be quiet in manner. Born November 19, 1849, Baxter was one of 13 children from his father's two marriages. John grew up on his father's farm, attending school in Auburn, Angola, and Butler. He entered the law department at Michigan State University at Ann Arbor, graduating in 1876. Borrowing $15 from a sister and securing a personal loan of $150 from an acquaintance, he bought a law library and began a practice in Butler. In 1880, the DeKalb County Circuit Court clerk passed away, and Baxter was appointed to complete the unexpired term. He was elected to a full term of four years the following fall. Following his term, Baxter resumed the practice of law in Auburn. Personally, he was a likable and interesting conversationalist. In November 1877, he married Ella Chamberlain, with whom he had six children. John and Ella both died at early ages. One son, Frank, followed in his father's footsteps and practiced law with the elder Baxter for four years before losing his life in the New Aveline Hotel fire, which occurred in Fort Wayne while Frank was there on a business trip. (Courtesy of John Bry.)

Richard "Dick" Boyd
Dick Boyd was the deputy sheriff in Auburn. He also owned and operated the Silver Moon Skating Rink during the later years of the rink's existence. It closed in about 1984 and was burned down by area fire departments in 1986. (Courtesy of the William H. Willennar Genealogy Center.)

Norman Gerig
Norman Gerig was the clerk of the DeKalb Circuit Court from 1969 to 1976 before being elected as an Indiana state representative in 1976, serving in that role until 1984. He also served the community as president of the Auburn Lions Club and president of the DeKalb County Free Fall Fair, while remaining active in his church and the DeKalb Gideon's. Gerig also served on the Auburn City Council, drove a bus for DeKalb Central Schools, was on the board of directors of DeKalb Financial Credit Union, and was a recipient of the Sagamore of the Wabash for his public service to the state of Indiana. (Courtesy of the William H. Willennar Genealogy Center.)

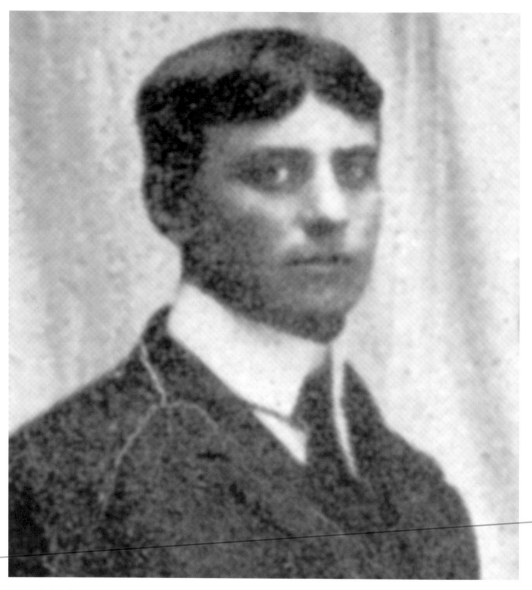

John P. Hoff
John P. Hoff became a prominent and successful man of Auburn with a well-respected and successful career. Born in Auburn on October 2, 1885, he was raised in his hometown and educated in public schools. He joined the community workforce at his father's grocery store and, later, became an employee of Auburn Steam Laundry. At age 19, he became a one-third owner of that business and, later, was half owner before selling it off and relocating to Rockford, Illinois, where he worked for White Swan Laundry. Less than a year later, he returned to Auburn and his father's store. In January 1909, he was appointed deputy under Sheriff Thomas. In the fall of 1912, he was elected sheriff of DeKalb County. At the time he took office, he was believed to be the youngest sheriff in Indiana, and there was only one who was younger in all of the United States. In 1909, Hoff was married to Lottie Wolford. Politically, he was a Democrat, and fraternally, he was a member of the Benevolent and Protective Order of Elks and the Knights of Columbus. Religiously, he was Catholic, and his wife belonged to the Methodist Episcopal church. (Courtesy of the William H. Willennar Genealogy Center.)

Francis Mark Hines, MD

Francis M. Hines was a longtime doctor and prominent figure in the Auburn and DeKalb County community. He was born in 1861 in Jackson Township to Henry and Sara Abigail (Smith) Hines, who came to the area sometime around 1839. The elder Hines was a farmer and justice of the peace for 18 consecutive years prior to being elected treasurer of DeKalb County in the fall of 1896. He passed away in July of the following year. At age 19, Francis began teaching school and continued until 1889, when he left to pursue a career in medicine at the Methodist Episcopal University in Fort Wayne. He earned his doctorate of medicine in 1892 and returned to Auburn and immediately established a successful practice as a doctor and surgeon. Hines served on the Auburn City Council during a period that saw the installation of a municipal light and water plant. It was largely through his efforts that it was completed at a cost much lower than anticipated. It is perhaps no surprise that he was then elected county treasurer in 1898 and served two consecutive terms. He also gave six years of service to the local school board while the Desoto School building was erected. In 1902, he became chair of the Democratic County Central Committee and served as a delegate to the national convention in St. Louis, where Alton B. Parker was nominated for the presidency of the United States. Francis married Lille Ann Carper in 1885. (Courtesy of the William H. Willennar Genealogy Center.)

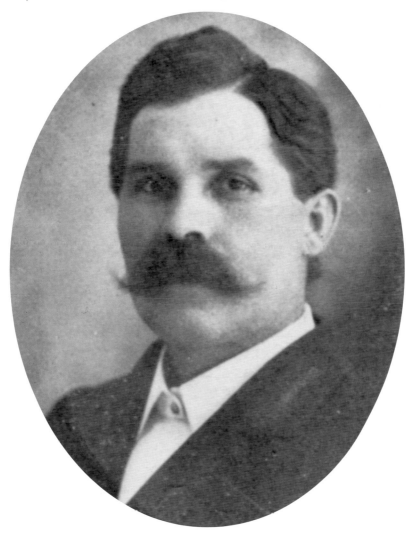

**Dorsey Mark Hines
and A.V. "Patch" Hines**
Francis and Lille Ann Hineses' sons
Dorsey Mark (left) and A.V. "Patch"
(below) followed in their father's
footsteps, both graduating from the
Indiana University School of Medicine
and practicing their profession in
Auburn. The Hineses' daughters Vera
Grace and Nellie Faith became local
schoolteachers. Three other children
died during infancy or at young ages.
(Both, courtesy of the William H.
Willennar Genealogy Center.)

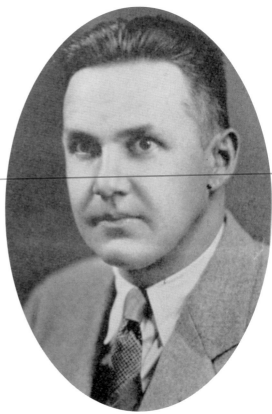

Walter "Squirt" Manon

Known by many in the community as "Squirt" due to his relatively small stature, Walter Manon was an accomplished Auburn High School athlete in both basketball and football, serving as captain while doing so. Standing just five feet three inches, the name, which was bestowed by Auburn High School coach Zeke Young, fit him well. As clerk of the DeKalb Circuit Court, he served during the terms of both Judges Walter Stump and Harold Stump. In 1956, Manon purchased a Texaco station on the south end of town, which is pictured below. He ran the station for two years, assisted by his son John Calvin Manon, who left for service in the Army. Following his service, John returned and joined his father in the purchase of another service station and, later, went into insurance sales before working at Cooper Standard for 30 years and then Feller & Clark Funeral Home for more than 20 years (in retirement). John also took to serving his community and Lord. At the time of this publication, he had served in the role of clerk of session for the Evangelical Presbyterian Church's Presbytery of the Midwest for approximately 15 years. Pictured below are, from left to right, Ron Larowe, John Manon, Sam Tarlton, and Walter "Squirt" Manon. (Both, courtesy of the William H. Willennar Genealogy Center.)

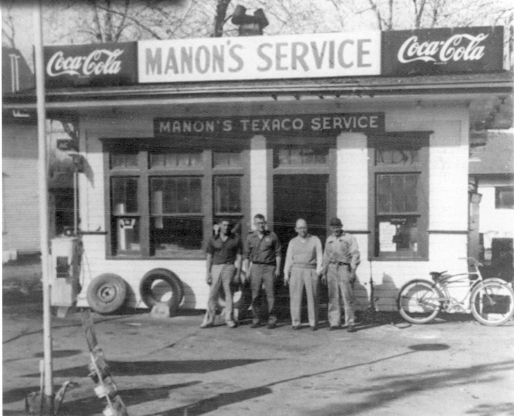

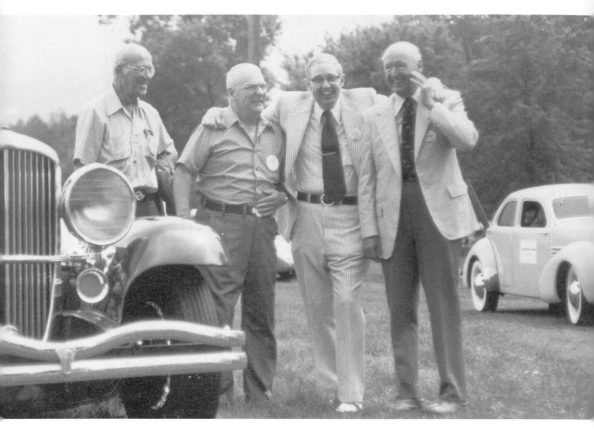

Gordon Buehrig

He is revered by many in the auto world as the man most responsible for leading Detroit out of the boxy age of the Model T and is often called the "Picasso of car designers." Given such acclaim, to say Gordon Buehrig was a longtime automobile designer with numerous creations is an understatement. During his career, his originality and passion prompted an association with many specialty car manufacturers as well as large manufacturers like the Ford Motor Company and General Motors. He briefly attended Bradley University before becoming an apprentice at a small auto body company in Wayne, Michigan. At 24 years old, he became chief body designer for Stutz Motor Company. A year later, in 1929, he was lured away by Duesenberg, where he designed half the company's prestigious line, including the "Twenty Grand." After exhibition at the 1933 World's Fair in Chicago, the car originally sold for $20,000. Through the E.L. Cord–led acquisition of Duesenberg, Buehrig came to work for the Auburn Automobile Company. Through the introduction of the 1935 Auburn Speedster, he helped salvage the company. The front-wheel-drive 1937 Cord 812 was honored by the Museum of Modern Art in 1951 as one of the finest autos ever designed and is among his most celebrated designs. In this photograph from September 1973 are, from left to right, Don Carr, Herb Newport, Mayor John Foley, and Buehrig. (Courtesy of the William H. Willennar Genealogy Center.)

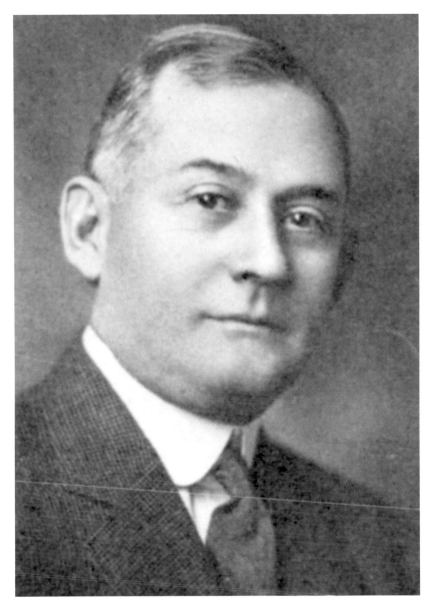

James I. Farley

Born just south of Hamilton, James Indus Farley (not to be confused with James Aloysius Farley) is most known as a three-term US congressman during the New Deal era of Franklin D. Roosevelt. He was educated at Tri-State College and Simpson College. In 1889, he became a schoolteacher and taught in both DeKalb and Steuben Counties. In 1906, he went to work in sales at Studebaker Corp., and he joined the Auburn Automobile Company in 1908 as a sales manager. There, he rose through the ranks to vice president and then president before stepping down in 1926. In 1928, he became a delegate to the Democratic National Convention and was elected to Congress in 1932, which he secured by defeating then incumbent Republican David Hogg. He was reelected twice before losing to Republican George W. Gillie in 1938. He passed away in 1948 and is buried locally in Woodlawn Cemetery along with his wife, Charlotte "Lotta" (Gramling) Farley. He was a founding board member of the YMCA. (Courtesy of the Auburn Cord Duesenberg Automobile Museum.)

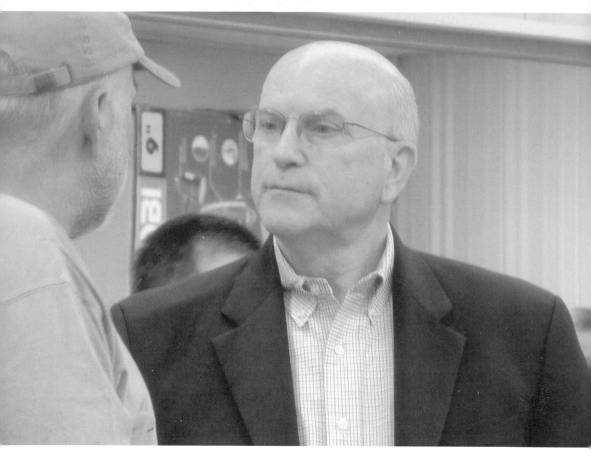

Dennis Kruse
A 1965 graduate of Auburn High School and 1970 graduate of the School of Education at Indiana University, Dennis Kruse has worked as an auctioneer, radio broadcaster, real estate broker, and an executive at Ambassador Steel Corporation. With his father, Russell W. Kruse, and brother Dean Kruse, he started an auction business that would become Kruse International. From 1989 to 2004, Dennis served as an Indiana state representative and was elected Indiana state senator for the 14th District in 2004, serving on the education and career development committee, the agriculture and small business committee, the pensions and labor committee, and the utilities and technology committee, among others. Kruse is a past president of the Indiana Auctioneer's Association and a member of its hall of fame; he also serves on the board of trustees at Trine University in Angola. (Author's collection.)

CHAPTER SIX

Entertainers and Athletes

Associate yourself with men of good quality if you esteem your own reputation for tis better to be alone than to be in bad company.

—Dr. Harland V. Hippensteel Jr.

This quote is not from a local legend associated with entertainment or athletics, but was said to be a primary, perhaps the only, credo by which Dr. Harland V. Hippensteel Jr. lived his life.

Hippensteel played high school basketball under legendary coach John Wooden, who, perhaps, also advocated much of the aforementioned credo. In order to focus on his studies and hold down work, Hippensteel declined an opportunity to play basketball while at Indiana University. Following the conclusion of World War II, in which Hippensteel served, another local legend, Dr. Bonnell Souder, encouraged Hippensteel to return to his hometown of Auburn. He eventually did so, setting up practice in 1950. And Auburn has certainly been the better for it.

In the history of the Classic City, many legendary locals have been entertaining on stages, theaters, and other forums. Similarly, they have left many in awe while displaying their given abilities on the baseball diamonds, basketball courts, football fields, and other fields of play.

Some of them, like Rollie "Polly" Zieder and Don Lash, rose to the highest heights of their chosen games. Meanwhile, others, like Jaynie Krick and Vivian (Refner) Gerst, broke through glass ceilings or other barriers to earn their rightful places as trailblazers and set new societal standards.

There were many who achieved their peaks in high school or perhaps college. Sadly, there are also stories of tragedy, such as those of Bill Kail and Earl Carr. Regardless, they became legends, albeit much before their time.

Of course, this chapter is by no means an all-encompassing list, but it serves as a starting point for others who wish to be among good company.

Olympian Don Lash
Peter F. Murphy Jr. took this photograph of Don Lash, wearing the black jersey, in 1936. Lash ran in the 1936 Olympics and won several world records along the way. Lash had an outstanding college career at Indiana University, and after finishing as runner-up the year before, he earned the Sullivan Award honors as the country's outstanding amateur athlete in 1938. While a student at Auburn High School, Coach Zeke Young encouraged Don Lash to give up football so he could concentrate on track. (Courtesy of the William H. Willennar Genealogy Center.)

FBI Agent Don Lash
Lash also had an interesting life beyond athletics. He was a special agent for the Federal Bureau of Investigation for 21 years and served as a trustee at Indiana University. He also was a 10-year member of the general assembly and was the first regional director for the Fellowship of Christian Athletes. (Courtesy of the William H. Willennar Genealogy Center.)

Bill Kail

A 1940 Auburn High School graduate, Bill Kail played football under coach Zeke Young and also boxed in Golden Gloves tournaments. He joined the Army Air Corps immediately upon graduation and was stationed in Corpus Christi, Texas, when debris from broken glass lodged in an eye during a flight. He was discharged following the incident. He later reinstated and joined the Marines. In his first action in Iwo Jima, he was fatally wounded at the age of 22 on March 15, 1945, while saving the life of a fellow serviceman. Following his passing, the street his parents lived on was named Iwo Street in Bill's memory. (Courtesy of the William H. Willennar Genealogy Center.)

Vivian "Pee Wee" (Refner) Gerst

When Vivian Refner was a student at Auburn High School in the late 1920s and early 1930s, she was a clear standout in girls' basketball; the game was played under the Iowa Girls Rules, which made the sport significantly different from today's game. She graduated in 1931 and took up bowling a few years later. She founded the Auburn Ladies Bowling Association and excelled, setting local records and winning the Central States Bowling tournament with a 602 series. She also used her bowling skills to support and fund several charitable causes and events. (Courtesy of the William H. Willennar Genealogy Center.)

Jim Schooley

In 1953, the Indiana University Hoosiers were crowned NCAA basketball champions. Though he did not score a point in the championship game, Jim Schooley played a pivotal role. That game's leading scorer for the Hoosiers was Don Schlundt, who usurped the starting center role from Schooley. Schlundt, while being recruited by Indiana University, was partnered with Schooley during a weekend branch visit, and Schlundt told Indiana University coach Branch McCracken that he would come to the school only if he could room with Schooley. Schooley, a champion nonetheless, went on to earn his doctorate in chemistry and had a 30-year career as a scientist with the National Institute of Standards and Technology (NIST). As an Auburn High School standout, he earned All-Conference, All-Sectional, All-Regional, All-Semi-state, and All-State team selections in his senior year. In 1979, he received the US Department of Commerce Gold Medal for Outstanding Scientific Achievement. The Gold Medal, first presented in 1949, is the highest honor conferred upon an employee of the US Department of Commerce, which is bestowed for "distinguished performance characterized by extraordinary, notable or prestigious contributions that impact the mission of the Department of Commerce and/or one operating unit and which reflect favorably on the Department." Schooley's high school coach Keith Showalter stated to the *Logansport Pharos Tribune* that Schooley "possessed extreme coordination in his finger tips, making him an accurate shot on the pivot."

The top photograph, taken by Kelso Davis, is of the Auburn High School 1948–1949 basketball team. Players are, from left to right, (first row) Bob Bates, Don Derrow, Jim Schooley, Ken McInturf, and Roger Wertenberger; (second row) manager Hugh Western, Bud McComb, Theo Webb, coach Keith Showalter, Barney Beers, Don Kelly, and Ted Miller. The bottom photograph was taken the Sunday after the March 1949 state tournament; pictured are, from left to right, Caroline Mitchell, cheerleader; Schooley; Don Kelley; Don Derrow (at microphone); Bob Bates (only half his face is showing); Milton Marx, radio announcer from Fort Wayne; Barney Beers; Ted Miller; Roger Wertenberger; Keith Showalter; and John Renner, cheerleader. (Both, courtesy of the William H. Willennar Genealogy Center.)

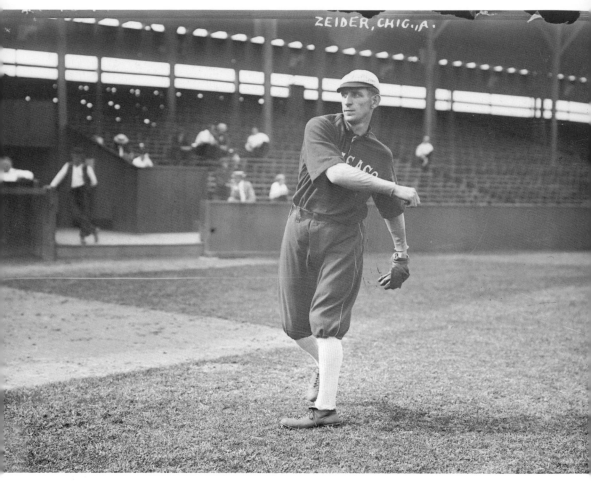

Rollie Zeider

Rollie Hubert Zeider was born in 1883 and is most known for his professional baseball career. He is one of only two 20th-century players to play in the same city for three different Major League–level teams and is the only person to hit home runs for all three Chicago Major League teams (Cubs, White Sox, and Whales of the Federal League). In his day, Zeider was known as one of the fastest players in the game. As a rookie with the Chicago White Sox, Zeider accomplished what would end up being his career high in stolen bases with 49. That number stood as the record for stolen bases by a rookie until 76 years later, when John Cangelosi, another White Sox player, broke it in 1986 with 50. The locals often called Zeider "Polly" because his large nose was said to make him resemble a parrot. However, following a bout of blood poisoning that occurred when Ty Cobb rammed his spike into his bunion during a play, he also earned the moniker "Bunions." In his only World Series appearance (1918 with the Cubs), Zeider had two plate appearances and walked twice. Following his baseball days, Zeider operated Polly's Tavern in Garrett until selling in 1959 and retiring. He was formally inducted into the Northeast Indiana Baseball Association Hall of Fame in 1966. He was battling leukemia at the time and was not able to attend the ceremony. He passed away in September 1967 and was buried beside his first wife, Alberta (Doyle), at Woodlawn cemetery in Auburn. He had no children but was survived by several nieces and nephews. (Courtesy of the Library of Congress.)

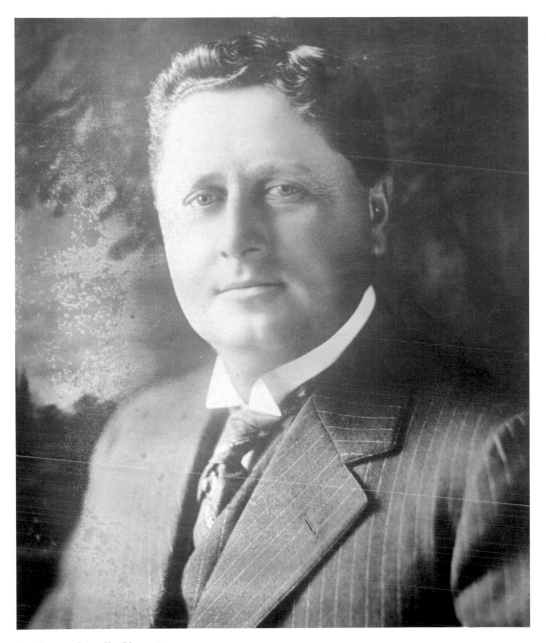

"Chicago Gang" of Investors
Better known for Wrigley's Chewing Gum or the Chicago Cubs, William Wrigley Jr. played a role in extending the life of the Auburn Automobile Company when he and a group of other investors, locally referred to as the "Chicago Gang," purchased controlling rights to the Auburn Automobile Company from the Eckhart brothers in 1919. They most likely saved the company from bankruptcy and irrelevance. The investors later hired a virtual unknown car salesman by the name of E.L. Cord to be their general manager. Cord struck a deal that saw him take no salary his first year of 1924 but would allow him the opportunity to gain controlling interest should he turn around the company's fortunes. In addition to Wrigley, Ralph Austin Bard, who later worked for Franklin D. Roosevelt and Harry S. Truman as under secretary of the Navy, was also part of the investment group. (Courtesy of the Library of Congress.)

Jaynie "Red" Krick

Six-year-old Jaynie Krick came to Auburn with her family when her mother bought out her sister's share of the Temple Café. The restaurant business was a recurring theme in the family, as brother Dick Krick had owned the Northway Inn, which was later bought by her sister and run for many years after. However, Jaynie was the athlete of the family. As a youth, Jaynie was considered tall for her age as she played for the Little Jewelry baseball team and also for the Bob Inn Restaurant and Bakery team in Fort Wayne, coached by restaurant owner Harold Greiner, who also had a hand in bringing the Fort Wayne Daisies to Fort Wayne. While playing on that team, a scout asked four of the girls to come to Comiskey Park in Chicago to try out for a newly formed women's baseball league. Jaynie, along with June Peppas, Katie Van Der Rohe, and Sally Meier all made the trek and earned places in the league. The 16-year-old Jaynie was assigned to the South Bend Blue Sox of the All-American Girls Professional Baseball League (AAGPBL). She was moved to Peoria the next year before taking a year off. When the league made plans to expand in Grand Rapids the next year, she was asked to rejoin the league, and she did. After playing a couple more years in the league, she left and played semiprofessionally in Chicago in another league. Following her professional baseball and softball days, she resided in many other cities throughout the United States and Canada as she established successful businesses, built power supplies while employed at Motorola, built gas tanks for airplanes during the war and coached basketball before returning to the Hoosier state. She was on hand for the induction of the AAGPBL players into the National Baseball Hall of Fame and appears in the movie *A League of Their Own*; she is the player kicking dirt on the umpire during the end credits. (Both, courtesy of Jaynie Krick.)

Hobart "Hobe" and Beatrice "Bea" Hart
Hobart "Hobe" Hart and his wife, Beatrice "Bea" Hart, were the owners of the Court Theatre and were regularly doing many good things for poor children. Hobe also ran small festivals throughout the Midwest and helped his nephew Robert S. "Bob" Hart Jr. open the Ohio Valley All-Sports Show at the Cincinnati Gardens in 1957, which was the forerunner to the well-known Cincinnati Travel, Sports & Boat Show. (Courtesy of the William H. Willennar Genealogy Center.)

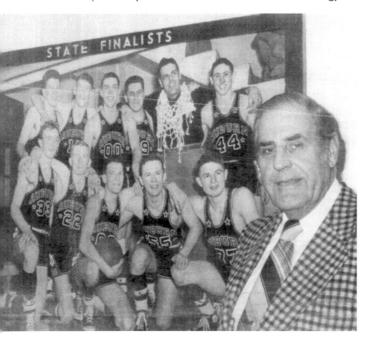

Keith Showalter
While a senior at Chester Center High School in 1933, Keith Showalter was the Wells County scoring champion and a three-year player at Ball State. He coached at his alma mater, Chester Center, for three years before Auburn. His 1949 Auburn Red Devils team went to the Indiana High School Athletic Association state finals in 1949, losing to Jasper. He was lured from Auburn to Logansport the next season, most likely enticed by the ability to choose student athletes from a group of about 1,000 versus a group of around 300 during his nine-year tenure in Auburn. Showalter also coached at Vincennes. His coaching career spanned 22 years, his legacy being his ability to pry high levels of excellence from his players, despite the fact that much of his career was spent at schools of modest enrollments. During his career, his teams won 14 sectionals, 7 regional titles, and a semi-state title. He was inducted into the Indiana Basketball Hall of Fame in 1978. A stickler for discipline, Keith gave all boys a chance to make the team, but in so doing, he required that they obey the training. (Courtesy of the William H. Willennar Genealogy Center.)

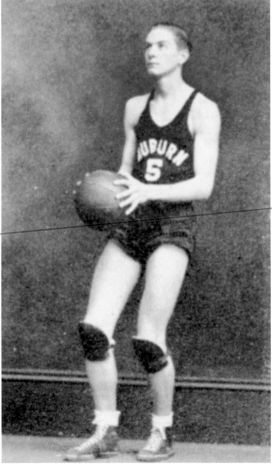

Earl Carr
Born March 20, 1920, Earl Carr was a standout athlete in football, basketball, and track while at Auburn High School, in addition to participating in the boys' chorus, the Future Farmers of America, and the Hi-Y Club. Nicknamed "Stretch," Carr went to the state track finals in the spring of 1937, finishing sixth in the state in hurdles. In the fall of that year, the right end of the Red Devils football team suited up for the final game against cross-county rival Garrett. He was injured during the game and left the field on his own. The pain had subsided the following day but returned the next and grew serious by Tuesday. Despite the doctors' best efforts, Carr lost his life as the result of internal injuries suffered during the game. The field that had been used by Auburn High School was later dedicated to Carr's memory. (All, courtesy of the William H. Willennar Genealogy Center.)

CHAPTER SEVEN

Newsworthy and Notable

Great things have been done by many common people. Perhaps they did not realize it at the time, but the advantage of historical hindsight can give them the recognition they deserve.

—John Martin Smith

This observation comes courtesy of the revered DeKalb County historian and legendary local, the late John Martin Smith. It was intentionally reserved to be an introduction to the final chapter because it so eloquently places the achievements of the present in historical context. What is more, it offers a glimpse of that common thread discussed in the introduction of this book.

The final section of legendary locals might be called a hodgepodge or potpourri of sorts. They should by no means be considered as miscellaneous or etceteras. Rather, they are to be revered as standouts and those who managed to live lives that were anything but common.

Some of them, such as Frank McDowell and John Peckhart, may seem noteworthy merely because of their place and time, while others like Bill Fitzsimmons, Rollie Muhn, and Martha Falka lived boldly, compassionately, or were of such impact that they are the topics of stories that have endured for generations.

Interestingly, the majority of the legendary locals who were interviewed for this book, and perhaps all of them, initially declined to be included. The John Martin Smith quote above was the go-to ammunition for breaking through their humility and getting them to relent from their stance.

Day in and day out, without realization, personal narratives are being written. Some choose to participate in the development of their own storylines with ambition and full force. Some are more casual and are content to allow life to happen. Regardless, time waits for no man or woman. The past gives a cornerstone for building upon while the future holds the heights of grandest ambitions.

What people do with today, as caretakers of the little pieces of time that have been gifted, becomes that common thread uniting all as legends in their own right.

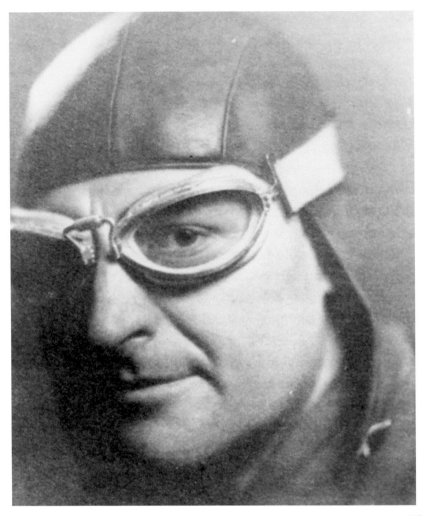

"Wild" Bill Fitzsimmons

Born with the given name of Guy Fitzsimmons, the young Kokomo, Indiana, chauffeur to an auto salesman came to Auburn by the graces of Morris Eckhart to be a test driver for the Auburn Automobile Company. He was no fan of his given first name and refused to tell his new coworkers what it was. So they began to call him Bill. The new name stuck after having evolved to "Big Bill," which his coworkers gave to him in order to differentiate between him and another employee of the same name. He later began driving a truck for the Auburn Foundry, where he expressed a love of flying. He began taking flying lessons in 1921 and, later, was able to purchase an airplane through the help of Auburn Foundry owner B.O. Fink. He stored his plane in Fort Wayne and would land it on a primitive strip just north of Seventh Street on Auburn's West Edge. E.L. Cord, upon seeing this, bought the strip and contracted with Rollie Muhn to build a hanger. Cord allowed Bill to house his plane there and never bothered to charge for it. Around the same time, Bill began learning to spin and perform other aerial acrobatics. He soon was performing aerial shows in many communities, transforming the man once known as Big Bill into "Wild" Bill. He taught Irvin Rieke to fly and that evolved into a deep friendship. Together, Bill and Irvin tried to break the land speed record and also had one of the earliest attempts at skywriting. Many residents believed that the fiery smoke they saw in the sky was a signal that the end of the world was upon them. Bill also was widely known as a practical joker. Many were outlandish, and some nearly provoked lawsuits. Bill died in 1986 at the age of 92. (Courtesy of the William H. Willennar Genealogy Center.)

John Roland "Rollie" Muhn

For more than a half century, residents of Auburn knew Santa Claus. In 1984, the year before his passing, the National Council for the Observance of Grandparents Day honored John Roland "Rollie" Muhn as one of 10 Grandparents of the Year. As a retired contractor, in addition to portraying Santa for local orphans and senior citizens, Rollie was a toymaker and proprietor of Silver Moon Toy Company, which he operated on East Seventh Street from 1931 through 1933. This is a photograph of Muhn as Santa holding Emily (Shook) Smaltz. Despite his wearing of cowboy boots, Muhn's portrayal of Santa was so well known and warming that photographs of his likeness were sometimes made into Christmas cards. His construction company, located just south of the Silver Moon Dance Hall on Country Road 427, was used by the Silver Moon Toy Company to manufacture a line of wooden toys. The line included such items as walking cats and ducks, oxen and carts, horses, and milk delivery wagons. The toys were colorfully lacquered. Freight was shipped on the interurban line that ran adjacent to the site. (Courtesy of the William H. Willennar Genealogy Center.)

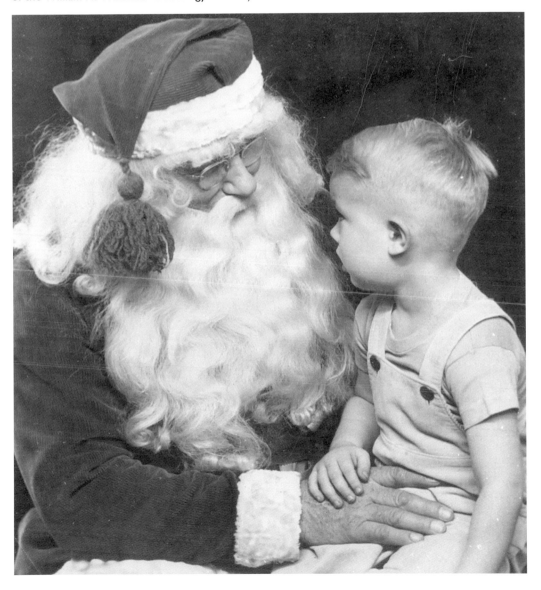

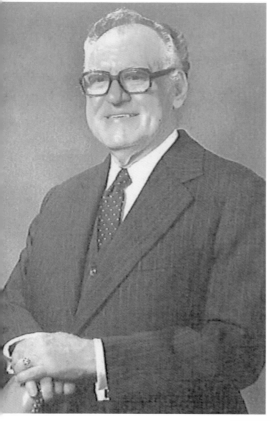

William Casley Killgallon

As a sales manager at the Auburn Rubber Company from 1945 to 1954, Bill Casley Killgallon would bring home samples of the company's "Stick on Soles" product, a rubber shoe tread or heel that could be glued to the bottom of a worn-out pair of shoes. Killgallon had his son serve as a product tester for the soles on the local basketball courts. In 1954, he left the Auburn Rubber Company for Ohio Art and eventually rose to president and chief executive officer of the company. While Killgallon was with the company, they paid $25,000 for the rights to a magical drawing toy that company executives first saw at a world's fair. Killgallon was intimately involved in naming the product the Etch-A-Sketch, and it soon began production at its Bryan, Ohio, factory. (Left, courtesy of Bill Killgallon Jr.; below, courtesy of the William H. Willennar Genealogy Center.)

Miss Indiana Teen World Roxanne "Roxie" Butler and Jennifer Grimm
Roxanne Butler (shown at left with Sen. Birch Bayh) is a communications executive and former journalist who worked at several television stations in Florida and Indiana. After being a journalist, she made a career shift to aviation strategic communications, which has included positions with two major US airlines and two multi-airport management teams in Texas and Indiana. In 2005, she was appointed by Gov. Mitch Daniels to direct communications for the Criminal Justice Institute and launched one of the governor's top statewide initiatives to fight the war on meth. This photograph is from 1980 when she won the state title as Miss Indiana Teen World, a teen scholarship pageant that judged young women on their public speaking, interpersonal skills, grade point average, and community volunteer work. In 1982, Jennifer Grimm (below) also was selected Miss Indiana Teen World. (Both, courtesy of the William H. Willennar Genealogy Center.)

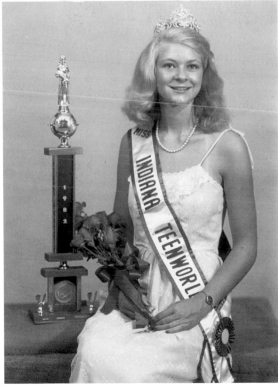

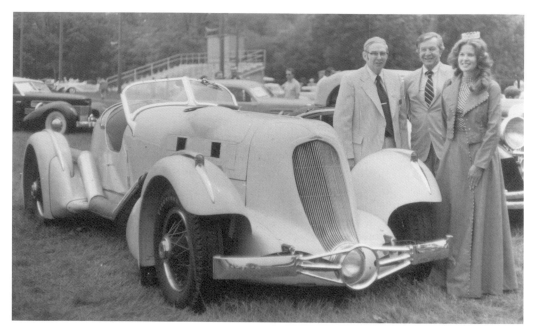

Miss DeKalb County Debbie Kerns and Mayor
Mayor John Foley (left) is joined by Miss DeKalb County Debbie Kerns and an unidentified gentleman during the ACD Festival in September 1973. They are at Carr Field adjacent to Eckhart Park. (Courtesy of the William H. Willennar Genealogy Center.)

Clint Stephens
Longtime DeKalb County Courthouse custodian, Clint Stephens turns the exterior of the building and immediate downtown area into a new canvas each year, with vibrantly colored flowers. He and his wife, Jeanne, begin planning the upcoming summer landscape months in advance, growing, transplanting, and caring for all the flowers around the courthouse and downtown area. When in full bloom, the appearance of the courthouse is one of the first things visitors to the area notice. (Courtesy of the William H. Willennar Genealogy Center.)

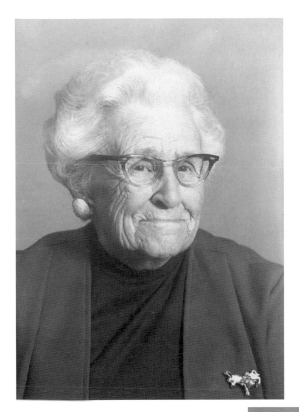

Frances Dulle
Frances Dulle worked for Stillman's Department Store for 25 years and volunteered at the Heimach Center, the Red Cross Blood Mobile, RSVP, Creative Play School, Eckhart Public Library's children's programs, and the local election board. She also wrote a weekly column for the *Evening Star* called "Spotlight on Seniors" and received the Sagamore of Wabash Award from Gov. Evan Bayh. She passed away in 2000. (Courtesy of the William H. Willennar Genealogy Center.)

Max Stanley "Tank" Brown
An Auburn High School graduate from the class of 1933, Max Stanly Brown received the nickname "Tank" because of the way he played on the football field for Coach Young. He later worked at the Auburn Rubber Company and Cooper Tire, retiring in 1978. Socially, he was a member of the Mizpah Shrine, ACD Club, and Elks lodge, and served on the board of trustees of the ACD Museum. He passed away in April 2002. (Courtesy of the William H. Willennar Genealogy Center.)

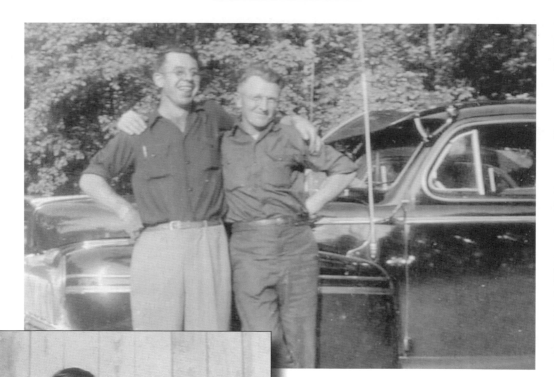

Alton E. Immel

Alton "Ham" Immel was a mechanic by trade, working as a machine operator for Warner Gear. He also operated his own lawn mower and automotive radiator repair shop from his garage on Union Street. From his shop, he did installations of his invention, positive traction rear end (positraction), which he called Twin Pull. He would also assemble the units in his shop and sell them at the Indianapolis Motor Speedway. The patent for Twin Pull was disputed and eventually lost. He was known to many as Ham, a nickname that has at least two origins, both involving his future bride, Audrey. One theory suggests he was showing off on a motorcycle in front of a group of girls that included Audrey—hamming it up—and ultimately wrecked the bike. The second suggests that while he was courting Audrey, he refused to come inside during their family dinners out of respect for the cost of providing for their large family, which included 13 children. Audrey's mother would give him a ham bone "to chew on" while he waited on the porch. (Both, courtesy of Dawn Immel Akins.)

Martha "The Popcorn Lady" Falka
Having lost her job in the mailroom at the Auburn Motor Company in 1940, Martha Falka visited a loan officer to discuss her plans for opening a popcorn stand in her community. Through the assistance of Amos Adams of the Auburn Federal Savings and Loan, she was able to purchase a popcorn burner from Bernice Wible. This paved the way to one of the most cherished Auburn traditions that has spanned generations. Martha opened her first business at Bishops' Ice Cream Parlor on east Seventh Street and, later, moved it to Ninth Street with the help of then mayor Jerry Oren. Families would enjoy evening walks in the downtown area, and while the paths of the strolls may differ, all of them found their way to Martha's little popcorn stand. Martha always insisted on real butter flavoring that soaked the brown paper sacks, and on occasion, she would prepare a batch of her special caramel corn, which always went fast. Upon her passing, rather than allow the stand to pass with Martha, Jack Randinelli purchased it and ensured the tradition would continue for more generations to come. (Courtesy of the William H. Willennar Genealogy Center.)

John Peckhart
John Peckhart was a former upholsterer for the Auburn Automobile Company. These are photographs of Peckhart standing in his upholstery shop, which was located on the throughway alley behind East Ninth Street. The photographs were taken by Roberta Andres. (Both, courtesy of the William H. Willennar Genealogy Center.)

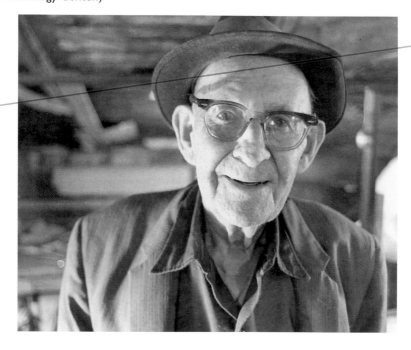

J. Frank McDowell and David Wolff
At left, in 1880, J. Frank McDowell became the first graduate of Auburn High School and, later, the city's civil engineer. Below, longtime principal at McIntosh Elementary School, which was previously the building that housed Auburn High School, David Wolff became the assistant to Mayor Norm Yoder after concluding his career in education. As a principal, Wolff was a kind and attentive educator who took an active interest in students' lives, earning their trust and friendship while helping to guide their values and development. (Both, courtesy of the William H. Willennar Genealogy Center.)

Mitchell "Mitch" Kruse

Mitchell, the son of Dean Kruse and grandson of Russell Kruse, was owner, chief executive officer, and auctioneer for Kruse International for 17 years, guiding it to a status of the world's largest collector car sales organization. He was the youngest licensed realtor in the nation and the first documented person to sell a vehicle for $1 million. He had a hand in developing the first auction to be broadcast live via satellite, the first auction streamed on the Internet, and the first auction produced on cable television (Financial News Network, forerunner to CNBC) as well as ESPN2, with several televised auctions reaching the highest ratings on their respective networks. He later sold Kruse International to pursue a calling to communicate God's word. He earned his master of arts and his doctorate of religious studies degrees with high distinction from Trinity Theological Seminary. As a volunteer teaching pastor at Blackhawk Ministries over a five-year period, his sermons were broadcast on Sunday mornings by the Fort Wayne ABC network affiliate. Today, Mitch writes and speaks to a wide array of audiences about Godly wisdom and leadership. (Both, courtesy of Mitch Kruse.)

Thomas R. Marshall

On May 18, 1910, the cornerstone of the Eckhart Public Library was placed. The moment represented the culmination of 13 years of work by many of Auburn's prominent and lesser-known citizens. The Indiana governor at that time was Thomas R. Marshall of Columbia City. Governor Marshall arrived in the morning and toured the city before the opening ceremonies at 1:30 p.m. J.A. McIntyre introduced Governor Marshall to a crowd of about 5,000. He then spoke with trademark eloquence that made him famous throughout the United States, providing fitting tributes and a conveyance that the city of Auburn and its residents always had a warm place in his heart. Also during his speech, he paralleled the symbolism of Eckhart's gift with the significance of the cornerstone being placed:

> By this act he has greatly enlarged his life. By giving the library to Auburn, he has demonstrated the wisest philosophy. It teaches men and women that the highest things to live for are not the things they gather to themselves but the good things they scatter abroad, such as kindly sentiments and generous judgments. This cornerstone will be a sermon long after the frame of the donor will have molded back to parent dust.

A year later, Marshall returned for the laying of the cornerstone of the new county courthouse. A week before, he had announced his candidacy for US president, and it was his first public address since doing so. He went on to become vice president under Woodrow Wilson. (Courtesy of the Library of Congress.)

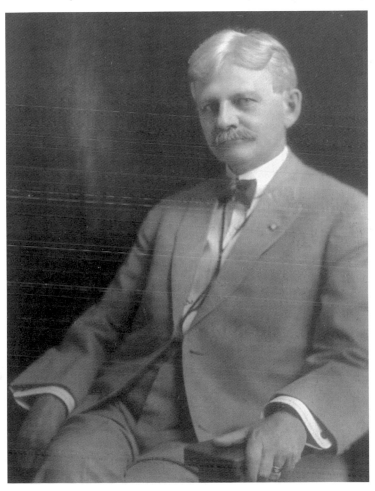

Legendary Locals and Classic Landmarks

This photograph is from the Cecil "Zeke" Young Collection at the Willennar Genealogy Center. It documents an aluminum drive for the National Defense Program in August 1941. It contains several legendary locals of Auburn and classic landmarks of the community's past. It was taken in front of the Court Theatre. Other buildings in the photograph include, from far left to right: Master Bakery, which was located on the northeast corner of Seventh and Cedar Streets; the Gerig Furniture Store, on the southeast corner of Seventh and Cedar Streets; the Auburn Diner; and the Court Theatre. The man in the truck wearing a hat and holding an aluminum pan is Dr. A.V. "Patch" Hines. David Rohm is handing an aluminum piece to Hobart "Hobe" Hart, the owner of Court Theatre. Walter "Red" Kail is the boy holding the dog. His sister Marilyn Kail Carr is the little girl looking toward the theater. The two Boy Scouts standing in front of the Court Theatre sign are William McClearly (left) and Budd Bassett (right). (Courtesy of the William H. Willennar Genealogy Center.)

"Auburn Forever, with Honest Endeavor"

A quiet and unassuming man who had no ambition for public position or leadership, John Zimmerman contributed much to the advancement of Auburn. Born in Leo in 1868, he moved to Auburn with his family in 1875. At age nine, he began to work in the Zimmerman Manufacturing Company factory when not in school. At 12, he had been placed in charge of the engine room. After completing high school, he went to a business college in Fort Wayne. In 1886, he went into the office and took charge of the books, acting as secretary, though not officially elevated to the post until 1889. In 1910, upon the death of his brother Franklin, he was made general manager of the company. It had evolved from being a simple mill to a builder of windmills, buggies, and automobiles. John Zimmerman was an important factor in the success the company achieved, being credited with great business ability, wisdom, and vision. Zimmerman was elected to the town board in 1898 and was a member of the city council during a time in which many city improvements took place, including the electric light, water works, and the sewer system, in addition to the paving of streets. In 1891, John Zimmerman married Clara E. Altenburg. Their son Joe originated a slogan that was used by the Commercial Club for many years following a contest in the spring of 1912. The slogan suggested by Joe Zimmerman was "Auburn Forever, with Honest Endeavor." (Courtesy of the William H. Willennar Genealogy Center.)

INDEX

BIBLIOGRAPHY

As previously acknowledged, this book draws heavily from many previously published resources in addition to private interviews with legendary locals and with those who knew legendary locals who are no longer living. The most utilized sources are cited below. Any of them will offer a wonderful ability to dig deeper into the history of the Auburn community and those who dwell within it. Most or all of them are now available in electronic format in various places online. Printed versions and many more resources are available at the William H. Willennar Genealogy Center located in Auburn.

Ford, Ira. *History of Northeast Indiana: LaGrange, Steuben, Noble and DeKalb Counties.* Chicago, IL: Lewis Publishing Company, 1920.

History of DeKalb County, Indiana: Together with Sketches of Its Cities, Villages and Towns . . . and Biographies of Representative Citizens: Also a Condensed History of Indiana. Chicago, IL: Inter-state Publishing Company, 1885.

History of DeKalb County, Indiana with Biographical Sketches of Representative Citizens and Genealogical Records of Old Families. Indianapolis, IN: B.F. Bowen, 1914.

Kruse, Mitch, and Derek Williams. *Restoration Road: The Master Key to a New and Satisfied Life of Authenticity.* Grand Rapids, MI: Credo House Publishers, 2009.

Roberts, Rachel Sherwood. *Auburn Is a Dancing Lady: A Guidebook.* Auburn, IN: Hawthorne Publications, 1999.

Sauer, Lee Philipp. *The Many Lives of Glenn T. Rieke: A Biography.* Auburn, IN: Envision Graphics, 2000.

Smith, John Martin. *Auburn: The Classic City.* Charleston, SC: Arcadia Publishing, 2002.

———. *DeKalb County 1937–1987.* DeKalb Sesquicentennial Inc., 1990.

Widney, S.W. *Pioneer Sketches, Containing Facts and Incidents of the Early History of DeKalb County.* Auburn, IN: W.T. & J.M. Kimsey, Printers, 1859.

AN IMPRINT OF ARCADIA PUBLISHING

Find more books like this at
www.legendarylocals.com

Discover more local and regional history books at
www.arcadiapublishing.com

Consistent with our mission to preserve history on a local
level, this book was printed in South Carolina on American-
made paper and manufactured entirely in the United States.
Products carrying the accredited Forest Stewardship Council
(FSC) label are printed on 100 percent FSC-certified paper.